Fantasy Genesis
A Creativity Game for Fantasy Artists

CHUCK LUKACS

IMPACT
CINCINNATI, OHIO
www.impact-books.com

ABOUT THE AUTHOR

Chuck Lukacs has been illustrating for science-fiction and fantasy games and fiction for eleven years. He's worked in several mediums including oils (for Wizards of the Coast's *Magic The Gathering* trading card game), ceramics, papermaking, historical book crafts and wood engraving. Chuck's work has been shown in galleries and conventions, and resides in museum collections and homes around the globe.

He has been influenced by the many craft revival movements throughout history, such as Japan's ukiyo-e period, the pre-Raphaelites, art nouveau, the Brandywine School and music poster art of the 1960s and 1970s—and their hip-hop torch bearers—not only for their techniques, but also for their ability to create positive social change through supporting handcraft.

Buddhism, Taoism and other world religions have played a large role in terms of Chuck's philosophical influences. He keeps on top of global political and economic news every day, is an activist and advocate of the modern progressive and peace movements, and believes poets, writers, actors, artists and creatives have a duty to promote an ideology of international peace.

Chuck is about as batty as a gooseberry submarine, bereft of any useful social skills and prone to extraordinary lapses of common sense. He stays up late into the morning dreaming his daft-wit little dreams and bringing them to light. When he is not pushing pencils and paint around, he practices traditional archery, thinks about solar and wind projects, electric NASCAR, craft brewing, musical effects and instruments, and windup toy design. If you don't believe it, see for yourself at www.chucklukacs.com.

 Other fine IMPACT Books are available from your local bookstore, art supply store or online supplier. Visit our website at www.fwmedia.com.

14 13 5 4 3

DISTRIBUTED IN CANADA BY FRASER DIRECT
100 Armstrong Avenue
Georgetown, ON, Canada L7G 5S4
Tel: (905) 877-4411

DISTRIBUTED IN THE U.K. AND EUROPE BY DAVID & CHARLES
Brunel House, Newton Abbot, Devon, TQ12 4PU, England
Tel: (+44) 1626 323200, Fax: (+44) 1626 323319
Email: postmaster@davidandcharles.co.uk

DISTRIBUTED IN AUSTRALIA BY CAPRICORN LINK
P.O. Box 704, S. Windsor NSW, 2756 Australia
Tel: (02) 4577-3555

Library of Congress Cataloging-in-Publication Data
Lukacs, Chuck.
 Fantasy genesis : a creativity game for fantasy artists / Chuck Lukacs. -- 1st ed.
 p. cm.
 Includes index.
 ISBN 978-1-60061-337-1 (pbk. : alk. paper)
 1. Fantasy in art. 2. Drawing--Technique. I. Title. II. Title: Creativity game for fantasy artists.
 NC825.F25L85 2010
 743'.87--dc22 2009036420

Edited by Mona Michael
Production edited by Mary Burzlaff Bostic
Designed by Wendy Dunning
Production coordinated by Mark Griffin

METRIC CONVERSION CHART

To convert	to	multiply by
Inches	Centimeters	2.54
Centimeters	Inches	0.4
Feet	Centimeters	30.5
Centimeters	Feet	0.03
Yards	Meters	0.9
Meters	Yards	1.1

ACKNOWLEDGMENTS

Gracious thanks to Mona, Wendy, Pam, and all the folks at IMPACT Books from editorial to sales and marketing. You've made this concept game of mine into the amazing book that it is. Thanks to all the kind art directors from Wizards of the Coast and Paizo for supporting my work over the years. Thanks most of all to the gamers and fans who support the arts and believe artists can make positive change in our society and on our planet.

DEDICATION

To all my friends and family, your smiles and steady support are what keeps me creating. To those who excel, without proper means or opportunity. To the survivors of threatening illness, damage and disease. To those who carry on with bright eyes and hopeful hearts after losing everything. To those who find more strength in fighting for peace and the unity that is inherent in our cultures and mythologies rather than resorting to ignorance and violence. To all those who can remember the dreams of their youth, using all their skills and all their strengths to fulfill them.

CONTENTS

BASIC DRAWING

This section provides practical drawing instruction for creating the different elements on the **Sets** and **Lists**.

PLAYING FANTASY GENESIS

Fantasy Genesis aims to provide you with the tools to play the game on your own, but to get you started, follow along with the author as he demonstrates how gameplay *might* go and how you might use the drawing skills you learned in the Basic Drawing section. Follow along with the author, step-by-step, as the author demonstrates gameplay: rolling the dice, choosing words from the lists and creating sketches combining the new concepts formed from the words. How the game *actually* goes is up to you as you come up with your own totally unique concept drawings!

Introduction

Welcome fantasy geneticists! Here is a practice place of the imagination, a place where infinitely diverse forms and patterns will create concepts in infinite combinations, which you will bring to light with pencil and paper. One of the most important jobs we have as artists is to create inventive new ways of watching and documenting this beautifully diverse planet that allows us to live on it. We're expected to see the world—from our cultures, habitats and technologies to the vast diversity of wildlife and plant life to the pores in our skin—in a slightly different light. Like scientists, we're expected to experiment with new ways of expression, new sounds, new interpretations of old ideas, new solutions to old problems and new inspirations for images and change.

Materials for the Fantasy Geneticist

All artists go through a period when they experiment and discover what techniques they like and what materials work best with these techniques. I've found that it's worth getting higher-quality materials, but there is nothing in this book that you can't do with just a set of dice, a pencil, paper and your imagination. Check the "Stuff for the Lab" sidebar for a complete list. Here are a few notes to keep in mind about the materials:

- **Traveling or sketchbook journal**. The better to draw straight from life and anytime the moment takes you.

- **Strong semitransparent paper**. I erase and re-draw quite a bit, and I sometimes want to re-draw and trace what's in my sketchbook. Along with my traveling sketchbook/journal, I use a big pad of semitransparent paper. I get tighter sketches with Bienfang Graphics 360 marker paper.

- **Pencils**. Keep a couple pencils around. Once one goes dull, use it for thick outlines and switch to a sharp one. I like Tombow Mono Professional pencils, B hardness.

- **Scrap paper**. Place a plain sheet of paper under your drawing hand to overcome excessive scumming. Or you can use that scumming by rubbing in tone to the shadow areas of your sketch, and erase highlights, using your eraser like a paintbrush.

- **Technology**. If you have a scanner or digital camera and computer, you can manipulate your sketches in an almost infinite number of ways. I erase highlights too small to get by hand and stretch or move different body parts to make a better design. I also use the computer to look up photo reference while I work. But I mostly use the computer to print and transfer the final sketch onto illustration board.

Skully dice supplied by Q-Workshop www.q-workshop.com

STUFF FOR THE LAB

DICE
- 2 six-sided dice
- 1 four-sided die
- 1 eight-sided die
- 1 twenty-sided die

DRAWING TOOLS
- 2-inch (51mm) brush (for shavings)
- B pencils
- Thin, pencil-shaped erasers or any gray/white eraser
- Circle and combination ellipse templates
- French curve
- Sketchbook and scrap paper
- Translucent marker paper

Photo Reference

Since the dawn of photography, illustrators have used photographic reference to bring more realism to their work. Some illustrators even hired photographers to follow them through the countryside snapping pictures of people, animals and landscapes that would make a stunning and believable painting. Fantasy art is no different. Every time you roll in *Fantasy Genesis*, look up a couple pictures for that roll to help you sketch.

SEARCHING FOR REFERENCE

With a computer and a couple good search engines we have libraries of photographic reference at our disposal without even leaving our drawing table. When you're looking up reference on your computer, you'll get a lot more pictures with much more detail if you're specific. If you're looking up a shark, first look at a site that's all about sharks. Then, when you find a certain kind you like, such as a hammerhead, look for pictures on hammerhead sharks. You'll find good pictures for broccoli, but search for Romanesco cauliflower and see what you get!

BRING A CAMERA AND TAKE IT YOURSELF!

Visit libraries, natural history museums, science museums and displays, and snap pictures of all that's inside them and outside. Take a trip to the aquarium or the zoo, or to a car show or technology display.

RECOMMENDED BOOKS

Animal by Smithsonian Institution and DK Publishing

An Atlas of Animal Anatomy for Artists by W. Ellenberger, H. Baum and H. Dittrich

Atlas of Human Anatomy for the Artist by Stephen Rogers Peck

Expedition: Being an Account in Words and Artwork of the A.D. 2358 Voyage to Darwin IV, by Wayne Douglas Barlowe

Also look for "art of" books for your favorite video games and movies. There will be some of the very best concepts and creations in them.

There are also many books from IMPACT that can be invaluable reference; for example, *Comic Artist's Photo Reference: People & Poses* by Buddy Scalera.

How to Use Photo Reference

Look at the photo, then hide it from yourself for a while. Don't let your photo reference get in the way of creating what you want to create. Bend and twist the forms you see in the photo to suit your own needs, and draw from your memory of what you think it will look like.

Game Basics: Rolling It Into Existence

Fantasy Genesis is constructed around the familiar dice-rolled decision-making dynamic of role-playing games. Using a series of dice rolls, you'll learn to generate ideas, creations and drawings.

SETS AND LISTS

The game consists of four initial *Set* rolls:

Anima: animals, sea life, insects

Veggie: plants, fruits and vegetables

Elemental & Mineral: elements, rocks

Techne: technology, weapons

Each Set contains within it several *Lists*. The headings in the Sets and Lists tell you which dice to roll (d6 = six-sided die).

GAME SHEETS

As you complete the rolls, you'll fill in a *game sheet*. There are four games to choose from: Basic, Object & Weapon, Creature or Humanoid, depending on what you're going for. (See pages 138–141 for blank game sheets you can copy.)

The initial words you write down on the game sheets will become the guidelines that your conceptual ideas will evolve from. They are the building blocks of what could be a creature or humanoid that has never been seen or heard before now. It could very well be the first time an artist looks at these four words in the same context, and each of you will think of different ways to use them. I treat it like a magical event!

GAMEPLAY

The generation of the ideas goes in two steps: *Rolling* and *Pick & Group*.

Step One: Rolling

Begin by rolling the dice and filling out the game sheets.

1 Roll one word from each of the first four Sets to determine which lists to use.

2 Roll the indicated dice for each of the Lists to determine the words.

These rolls form the words you'll use in evolving your concept. As you roll, begin thinking of the sizes and shapes of form that could be taken from the words, their combinations and the many different ways body parts might look. Remember that anything is possible.

Step Two: Pick & Group

Choose the words from your game sheet that you want to explore. Keep your mind wide open for fun combinations to form. You don't have to use every word in each concept—that would look quite cluttered. But use at least two or three of those words to shape your concept.

There is no telling what kinds of things will pop into your head; much of this step is a willingness to look past the words themselves. Take each word, one by one, and think of all the ways it could be drawn. Dissect each word into the many different parts of its form. Perhaps you want to use its whole major form, or just a specific part of its mechanism or body part—fingers, legs or roots—as a minor form. Can you use its pattern as a surface or skin? Think about its motion or function, its size and how it might be fun to shrink or expand.

IMPORTANT! DICE SHORTHAND

Many of you might know this, but just in case … Players of role-playing games use dice to decide just about everything, from their characters' abilities to whether or not they win fights. To communicate how many and what kind of dice to roll, they use this system. The first number plus the letter "d" tells you how many dice to use. The second number tells you how many sides the dice should have. So 2d6 means two six-sided dice, 1d8 means one eight-sided die and so on.

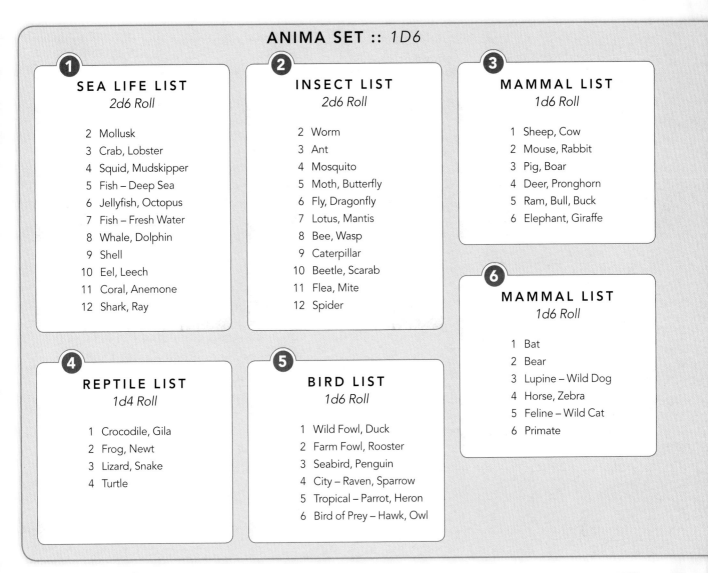

ANIMA SET :: 1D6

① SEA LIFE LIST
2d6 Roll

- 2 Mollusk
- 3 Crab, Lobster
- 4 Squid, Mudskipper
- 5 Fish – Deep Sea
- 6 Jellyfish, Octopus
- 7 Fish – Fresh Water
- 8 Whale, Dolphin
- 9 Shell
- 10 Eel, Leech
- 11 Coral, Anemone
- 12 Shark, Ray

② INSECT LIST
2d6 Roll

- 2 Worm
- 3 Ant
- 4 Mosquito
- 5 Moth, Butterfly
- 6 Fly, Dragonfly
- 7 Lotus, Mantis
- 8 Bee, Wasp
- 9 Caterpillar
- 10 Beetle, Scarab
- 11 Flea, Mite
- 12 Spider

③ MAMMAL LIST
1d6 Roll

- 1 Sheep, Cow
- 2 Mouse, Rabbit
- 3 Pig, Boar
- 4 Deer, Pronghorn
- 5 Ram, Bull, Buck
- 6 Elephant, Giraffe

⑥ MAMMAL LIST
1d6 Roll

- 1 Bat
- 2 Bear
- 3 Lupine – Wild Dog
- 4 Horse, Zebra
- 5 Feline – Wild Cat
- 6 Primate

④ REPTILE LIST
1d4 Roll

- 1 Crocodile, Gila
- 2 Frog, Newt
- 3 Lizard, Snake
- 4 Turtle

⑤ BIRD LIST
1d6 Roll

- 1 Wild Fowl, Duck
- 2 Farm Fowl, Rooster
- 3 Seabird, Penguin
- 4 City – Raven, Sparrow
- 5 Tropical – Parrot, Heron
- 6 Bird of Prey – Hawk, Owl

Rolling the Sets and Lists

These are the Lists for the Anima Set. The title, Anima Set 1d6, tells you to roll one six-sided die. For example, say you roll your six-sided die, and you get a 2. That takes you to the 2 Insect List. The 2 Insect List tells you to roll two six-sided dice. You roll your two six-sided dice, and they add up to 7. You then write "Lotus, Mantis" on your game sheet in the indicated box.

EMOTION AND ACTION LISTS

In addition to the four Sets (Anima, Veggie, Elemental & Mineral, and Techne), which contain twenty Lists, there are also two additional Lists. Those are the Emotion List and the Action List. Consider these as extras to be used when you need them for creatures or humanoids.

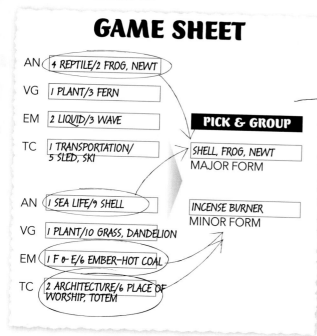

GAME SHEET

AN (4 REPTILE/2 FROG, NEWT)

VG | 1 PLANT/3 FERN |

EM | 2 LIQUID/3 WAVE |

TC | 1 TRANSPORTATION/ 5 SLED, SKI |

PICK & GROUP

| SHELL, FROG, NEWT |
MAJOR FORM

AN (1 SEA LIFE/9 SHELL)

| INCENSE BURNER |
MINOR FORM

VG | 1 PLANT/10 GRASS, DANDELION |

EM (1 F & E/6 EMBER—HOT COAL)

TC (2 ARCHITECTURE/6 PLACE OF WORSHIP, TOTEM)

Filling Out a Game Sheet

Step 1 :: Roll

1 Roll to get one word from each of the first four Sets.

2 Roll the indicated dice for the List rolls.

Step 2 :: Pick & Group

Choose the words you want to explore. Look at each word and think of all the ways you could draw it. Then choose a word for a *Major Form* and a *Minor Form*. Major Form and Minor Form words do not have to come from the Lists. It's possible that these words are just inspired by the Lists.

Fantasy Genesis in Action

I chose "Shell" for one of my words. My first thoughts were about the amazing pattern of a nautilus shell. I also thought about how the form of a clam might look as ears or hornlike spinal protrusions. The words "Place of Worship" and "Ember, Hot Coal" made me think of incense and burners, so I picked both of them and combined them to form "Incense Burner." Go through each of your words like this. Don't be afraid to mix together several words.

VEGGIE SET :: 1D4

❶ PLANT LIST
2d6 Roll

2 Seaweed
3 Fern
4 Desert Cacti
5 Thick leaf – Jade
6 Flower – Domestic
7 Vine
8 Poppy
9 Grass, Dandelion
10 Bamboo
11 Flower – Wild
12 Carnivorous

❷ FRUIT & VEGETABLE LIST
2d6 Roll

2 Asparagus
3 Pinecone
4 Berry, Grapes
5 Ginger
6 Tree Fruit (Apple, Orange)
7 Bean
8 Pumpkin, Gourd
9 Broccoli, Artichoke
10 Corn
11 Grain, Wheat
12 Pineapple

❸ FUNGI LIST
1d4 Roll

1 Moss
2 Ooze, Jelly
3 Lichen
4 Mushroom

❹ TREE LIST
1d6 Roll

1 Willow
2 Birch
3 Maple, Oak
4 Banyan
5 Pine
6 Palm

ELEMENTAL & MINERAL SET :: 1D4

1

FIRE & ELECTRIC LIST
1d4 Roll

1. Fire, Vapor
2. Electric Bolt
3. Ember, Hot Coal
4. Molten Lava

2

LIQUID LIST
1d8 Roll

1. Icicles
2. Fog, Vapor
3. Wave
4. Dew Drops
5. Ripple
6. Frost, Snow
7. Suds, Bubbles
8. Tar, Gum

3

EARTH & METAL LIST
2d6 Roll

2. Malachite
3. Mountain, Cliff Face
4. Brick, Cobblestone
5. Rust, Oxide
6. Cracked Clay
7. Stalactite, Stalagmite
8. Glass, Crystals
9. Powder, Sand
10. Slate, Shale
11. Cement, Sediment
12. Mercury, Chrome

4

ASTRAL & ATMOSPHERIC LIST
1d8 Roll

1. Moon Cycles
2. Starfield
3. Crater, Asteroid
4. Solar Flare
5. Galaxy Form
6. Volcano
7. Planets, Saturn's Rings
8. Cloud, Cyclone

TECHNE SET :: 1D6

2

ARCHITECTURE LIST
1d8 Roll

1. Ornament, Gargoyle
2. Bridge, Framework
3. Castle, Domed
4. Ornament, Pillar
5. Modern Skyscraper
6. Place of Worship, Totem
7. Doorway, Archway
8. Old Village, Cottage

3

TOOL LIST
2d6 Roll

2. Drill
3. Cups, Plates
4. Umbrella
5. Bundle, Bale
6. Hammer, Axe
7. Brush – Hair, Tooth
8. Razor, Knife
9. Spigot, Faucet
10. Rope
11. Silverware
12. Lock, Key

1

TRANSPORTATION LIST
1d8 Roll

1. Car, Truck, Bus
2. Aircraft
3. Rail, Train, Trolley
4. Cycle
5. Sled, Ski
6. Boat, Ship
7. Spacecraft
8. Tank Tread

5

TOOL LIST
2d6 Roll

2. Adhesive, Bandage
3. Shovel, Pick
4. Capsule, Tablet
5. Nuts, Bolts
6. Chain
7. Thread, Stitch
8. Shears, Scissors
9. Pen, Paintbrush
10. Spring, Coil
11. Syringe
12. Tube, Plumbing

6

MACHINE LIST
1d8 Roll

1. Reactor Core
2. Telephone
3. Solar Panel
4. Engine
5. Laser Beam
6. Microchip
7. Dish Antenna
8. Rocket

4

MACHINE LIST
1d6 Roll

1. Switch, Dial, Button
2. Turbine
3. Bulb, Lamp
4. Clock, Gears
5. Fan, Propeller
6. Saw

Rules to Be Broken :: Tips on Free-Form Imagination

This game began for me as a solution for a bad case of creative block. The scheduled assignments had gone away after I left school, and it was difficult to make something creative and new without a starting point. So I invented a way to give myself assignments from a virtual teacher; this turned into the first version of *Fantasy Genesis*. It is a thinking game. The list of words themselves won't teach you to draw, but they will expand your skills through new possibilities and fun combinations.

After rolling countless times with these lists, I've learned some tips that may help you in your sketching and in developing your imagination.

ROLL OVER

You are not beholden to the characteristics that you roll. If you see something on any of the lists that would fit better for your creation than what you rolled, go ahead and choose that word instead. There are no penalties. Ideas can also form differently if you roll each section in a different order.

SIZE AND SCALE

Always think about how big or small any part of any roll might be. You could make enormous stag horns that a fish creature lifts in attack, or give a humanoid the legs of a flea, or shrink Saturn's rings to form around the ankles of a humanoid. There are infinite combinations of sizes that you can give to any part of any roll—sometimes this simple thought is all you need to create something completely new!

PAIR UP FORMS

Replace anatomy and object parts. Mix it up. Put wings on a pig, mix the head of a mantis with the body of a gazelle, or place a doorway in the middle of a chest or hand. Playing around with the sizes and shapes of forms and mixing them together are the first things to consider with your list of words.

PAIR UP FORMS AND PATTERNS

Pay attention to patterns and markings of creatures and objects, then stretch them around other forms. Wrap the pattern of a tree frog or newt along the side of a space-craft, or add the texture of feathers to a tree trunk or incorporate the pattern of frost into a lion's fur. When using patterns it's wise to have a large area to place that pattern so you'll be able to sketch it there. Some good spots are the bellies and backs of creatures and humanoids, the wide blade of a weapon, the panel of a vehicle or the face of a building.

GROWTH AND DECAY

Think about the age of your creature or humanoid. Should it be fresh from the egg or hunched and wrinkly? Will the metal be shiny and new or falling apart with rust and pits? Will the tree branch be filled with foliage or bare? Always think about growth and decay, especially with any Veggie roll, as the change of the seasons might give you more ideas.

PREDATOR OR PREY

Will your creature or humanoid be an herbivore, carnivore or omnivore? Will it hunt energy, metal or stone? How will it eat?

CLIMATE

Will your creature or humanoid live in the tropics or the arctic? The habitats and temperatures in which animals and humans evolve affect the thickness or lack of fur.

WRITE IT DOWN QUICK!

Ideas come and go quickly. It is good to remember why you picked the combinations you did, as by the time you reach for your sketchbook your idea for a winged panda bear may just fly away. I sometimes sketch a thumbnail of what comes to mind right when I make the connection of how the creature or object might look, and save the sketch until I can flesh out the full gesture or play with different patterns.

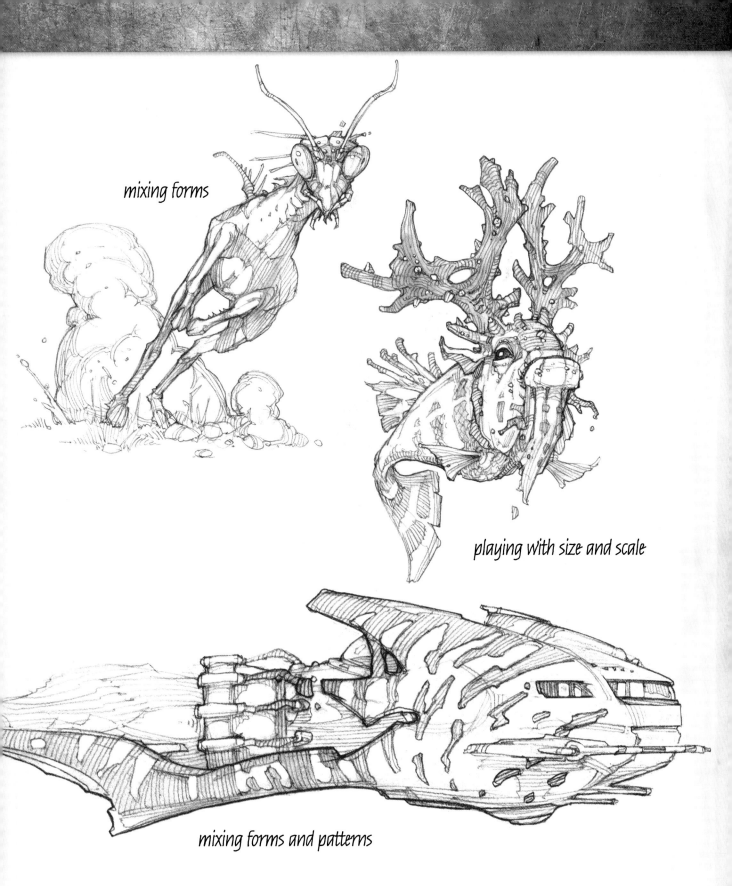

mixing forms

playing with size and scale

mixing forms and patterns

(1)

SEA LIFE LIST
2d6 Roll

2 Mollusk
3 Crab, Lobster
4 Squid, Mudskipper
5 Fish – Deep Sea
6 Jellyfish, Octopus
7 Fish – Fresh Water
8 Whale, Dolphin
9 Shell
10 Eel, Leech
11 Coral, Anemone
12 Shark, Ray

(2)

INSECT LIST
2d6 Roll

2 Worm
3 Ant
4 Mosquito
5 Moth, Butterfly
6 Fly, Dragonfly
7 Lotus, Mantis
8 Bee, Wasp
9 Caterpillar
10 Beetle, Scarab
11 Flea, Mite
12 Spider

(3)

MAMMAL LIST
1d6 Roll

1 Sheep, Cow
2 Mouse, Rabbit
3 Pig, Boar
4 Deer, Pronghorn
5 Ram, Bull, Buck
6 Elephant, Giraffe

ANIMA SET :: 1D6

④ REPTILE LIST
1d4 Roll

1 Crocodile, Gila
2 Frog, Newt
3 Lizard, Snake
4 Turtle

⑤ BIRD LIST
1d6 Roll

1 Wild Fowl, Duck
2 Farm Fowl, Rooster
3 Seabird, Penguin
4 City – Raven, Sparrow
5 Tropical – Parrot, Heron
6 Bird of Prey – Hawk, Owl

⑥ MAMMAL LIST
1d6 Roll

1 Bat
2 Bear
3 Lupine – Wild Dog
4 Horse, Zebra
5 Feline – Wild Cat
6 Primate

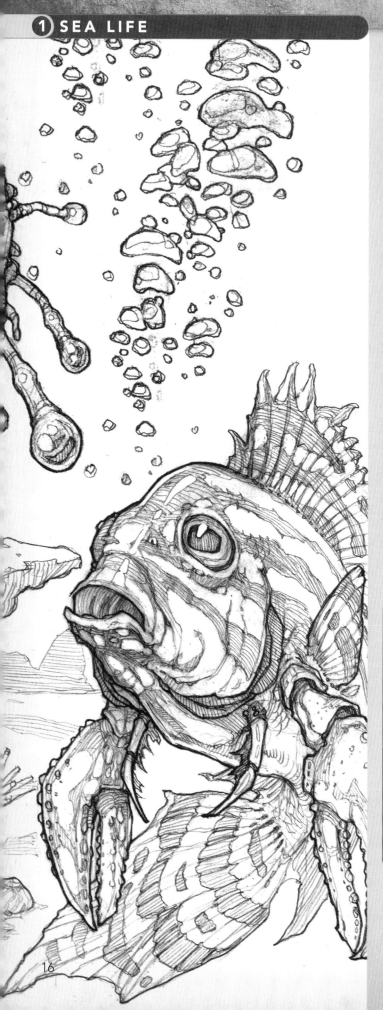

1 Sea Life :: 2d6

Welcome to the underworld, fantasy geneticists! Here in the Sea Life list, we discover some of the oddest things on our world: hammerhead sharks, crusted coral growths, slimy octopus tentacles, luminous eye stalks and the spiraling patterns of seashells.

The Census of Marine Life estimates that the lakes and oceans of this planet are home to some 230,000 different species of aquatic life and approximately 21,000 of them are varieties of fish. Fisherman culture has existed on every continent throughout history, and consequently mythologies have symbolized fish as everything from fiendish predators to benevolent deities. Evolving completely in water instead of air, their bodies and forms are more noticeably different than any life on land. They move without limbs, breathe through gills and can withstand freezing temperatures. Fish are wonderfully alien to us, and their forms and anatomical shapes can easily be used to show this mystery in your creations.

1

SEA LIFE LIST
2d6 Roll

 2 Mollusk
 3 Crab, Lobster
 4 Squid, Mudskipper
 5 Fish – Deep Sea
 6 Jellyfish, Octopus
 7 Fish – Fresh Water
 8 Whale, Dolphin
 9 Shell
10 Eel, Leech
11 Coral, Anemone
12 Shark, Ray

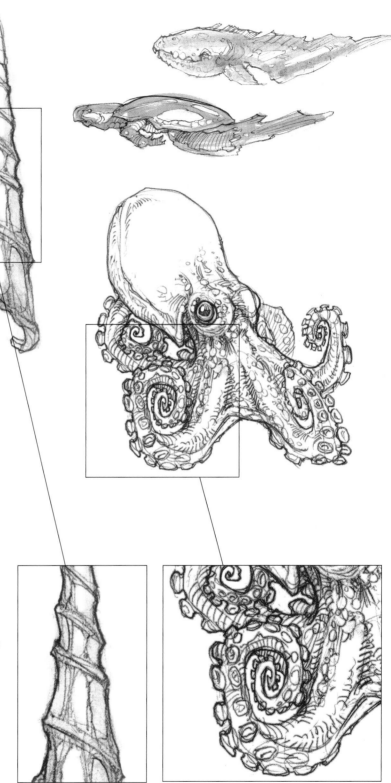

Mix and Match Form and Shape

Play with the many sea life body forms and shapes. Try placing the head of one on the body of another, or make a few body parts larger or smaller than they naturally appear.

Spirals

Spirals are a recurring theme in sea life. When creating spirals, it's useful to look at rope. At my table I keep a length of rope that I bend in the direction of tentacles. It will give you the tapering of shells and the S- and Z-shapes that wrap around the external form.

FINS AND CLAWS

In this demonstration, we'll draw a fish-crustacean hybrid, covering the basics of fish drawing along with the claws of a crab or lobster.

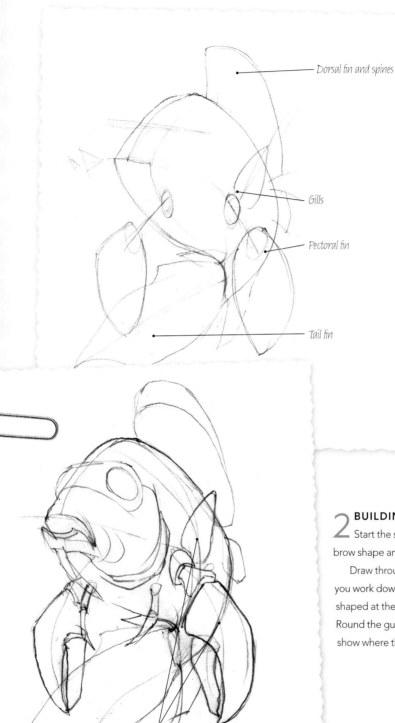

Dorsal fin and spines

Gills

Pectoral fin

Tail fin

Draw through. Even though you will erase these lines later, seeing them now will help you structure your creature.

1

SEA LIFE LIST
2d6 Roll

2 Mollusk
3 Crab, Lobster
4 Squid, Mudskipper
5 Fish – Deep Sea
6 Jellyfish, Octopus
7 Fish – Fresh Water
8 Whale, Dolphin
9 Shell
10 Eel, Leech
11 Coral, Anemone
12 Shark, Ray

SKETCHING THE BASIC SHAPES

Lightly sketch a curved centerline running from the mouth to the tip of the tail to give the major movement to the fish's body. Also draw in the shapes for the main body and the tail fin along the centerline, and add guidelines for the eyes and mouth. Draw another centerline up from the mouth, and sketch the dorsal fin shapes along it. Finish adding the other fish shapes, then add guidelines and circle points for the claws, placing the two hanging claw shapes at the ends of each.

2 BUILDING SECONDARY SHAPES

Start the secondary shapes from tip to tail: the mouth and gills, the brow shape and eyes, then the joint segments and claw pincers.

Draw through with the overlapping shapes, and erase guidelines as you work down the body. Claws can be similar to some horns: box-shaped at the base then smoothing to rounded curves towards the tip. Round the guidelines for the dorsal fin, and add a second guideline to show where the spines will break.

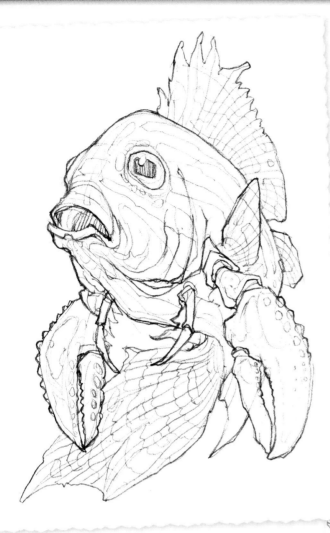

3 DESIGNING FINS, PATTERNS AND SHADOWS

Divide each fin into equally spaced spines from the body to the edge of the fin. They don't need to be perfect, but they should spread out from the body and sway along the centerline of the fish as a flag would in the air. Draw the front spines of the dorsal fin by ending each spine with its own tip, like feathers that trail off into the fin. When the spines are in place, begin mapping out the pattern guidelines. I chose a broken stripe pattern, but feel free to experiment. Patterns curve around all the ridges and forms along the body, and should run perpendicular to the spines of the fish's fins. Start to form more detail to the rest of your shapes by adding wrinkles, ridges and warts to the claws and eyes.

Finally, map out the guidelines for the areas that will fall in to shadow, keeping in mind that the hybrid fish is facing its light source.

Keep the spines equally spaced, and curve them along the fish's body.

WRINKLES, RIDGES AND WARTS

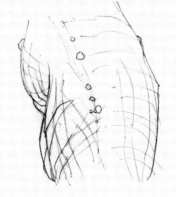

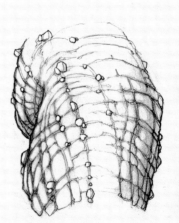

1 Begin with a few guidelines to create the form you're going to add wrinkles and warts to.

2 Lightly sketch crisscrossing lines that follow the contours of the form. Pick a couple lines that move through the entire form and add a series of warts where the skin creases.

3 Split the lines into individual ridges and wrinkles. Rub darks into the shadow areas where wrinkles gather, and erase the highlights on each shape between the lines.

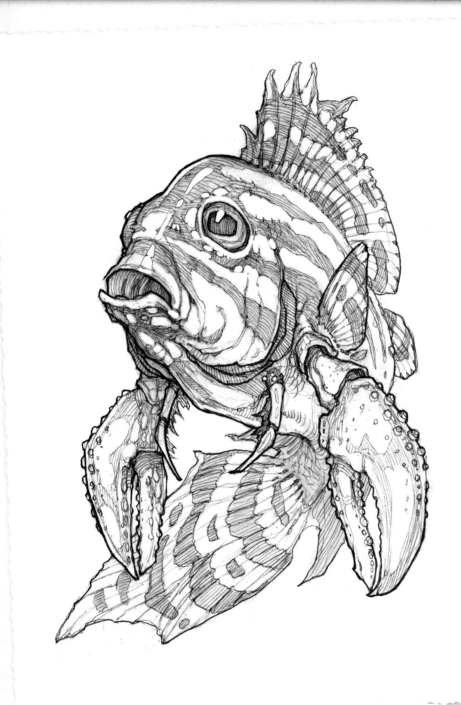

4 FINISHING

Fill in all of the pattern guidelines along the body and fins with tone and hatching. Pay special attention to sketching the pattern hatching lines in the same direction that the pattern moves, the direction of your original centerline. Darken in the shadow areas in the same way, and thicken the outlines of the major shapes and details. Erase any guidelines and tighten any details that have become muddy to bring out the contrast of both shadow and pattern.

HIGH CONTRAST = SHINY AND WET

Sea life is wet! Any sea life form you use will become more believable by giving a lot of contrast to the highlights. Look at how bright the highlights are on the forehead, through the parts of the mouth and on the eyeball. Like the highlights of polished glass, wet highlights will cut through any pattern and will make your sea life creations come to life.

JELLYFISH AND MOLLUSKS

Underwater life is so removed from our daily lives that when its influence is seen above water, we can't help but think we're looking at something from another part of the universe. These ancient life forms have lived in the depths of this planet's oceans since the beginning of life as we know it. They are gastropods, cephalopods and coelenterates, sifting through the cold dark waters for their sustenance. They tend to be insectlike with soft bodies covered in exoskeleton segments or hard shelling secreted as they grow; they are often able to retract into that shell for protection.

The soft-tentacled and shelled creatures of our oceans have such a wonderfully diverse variety of form and pattern that I had to concentrate on form. Here I mixed an ancient deep-sea hybrid creature with the eye stalks of a mudskipper, the hanging tentacles of a Portuguese man-of-war and a spiraling gastropod shell covered with tiny mollusks. Let's explore how any shelled Sea Life roll can become a beautifully alien creation.

1	SEA LIFE LIST
	2d6 Roll
2	**Mollusk**
3	Crab, Lobster
4	**Squid, Mudskipper**
5	Fish – Deep Sea
6	**Jellyfish, Octopus**
7	Fish – Fresh Water
8	Whale, Dolphin
9	**Shell**
10	Eel, Leech
11	Coral, Anemone
12	Shark, Ray

SKETCHING THE BASIC SHAPES

Roughly sketch the donutlike shape of the main shell. Place a horizontal line through the donut. The horizontal centerline should be a little closer to the top than to the bottom of the shell. Also draw a curved centerline down the front surface of the shell and another two guidelines on either side of it. Following these guidelines, sketch six circle shapes where the eye stalks will start, then draw centerlines for each, jutting out from the center of the circles. Draw in the circles for each eye stalk, measuring the lengths of them with your pencil to make each pair symmetrical. The bottom four eye stalks should be drawn with an eyeball shape at the end and a knuckle shape midway down the length. Then connect each circle with lines curving in towards the centerline.

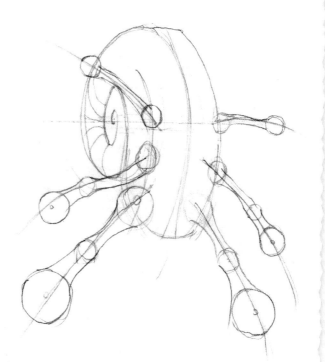

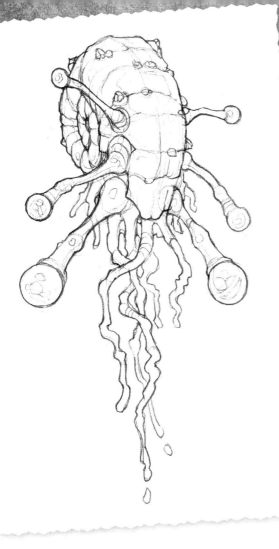

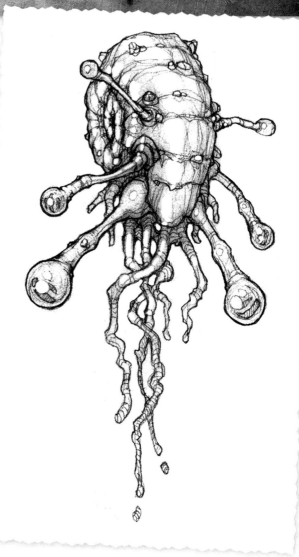

2 BEGINNING DETAILS

Roughly sketch in the segments and ridges of the shell's growth as they curve around the shell. They don't have to be perfect, as our hybrid is old and filled with mollusks, but for good perspective they should curve out from the vertical guideline running through the center of the spiral. Detail the shapes of your eye stalks and add in the irises and highlights of the eyeballs to show that they are as smooth as glass. Sketch in random warts and tiny mollusks growing along the ridges of the hybrid and the mass of tentacles hanging beneath it. Then mark out where the shadows and highlights will form underneath each ridge and form, and erase your guidelines.

3 FINISHING THE DETAILS

Finish by rubbing and hatching in the shadow areas underneath and to the sides of every ridge and form. Add more wrinkle details and mollusks. Erase the highlights and gaps in the forms, and darken the outlines.

PLACING SHADOWS AND LIGHT

The lightest section of any form is where the light hits it directly. With deep-sea photography this is often in the center. On the hybrid here, notice the lightest section in the center where the light hits the middle of the shell and stalks. The darkest sections occur around the ridgelines that divide the shell, so you place shadows toward the edges of the form and highlights fairly close to the center of the form.

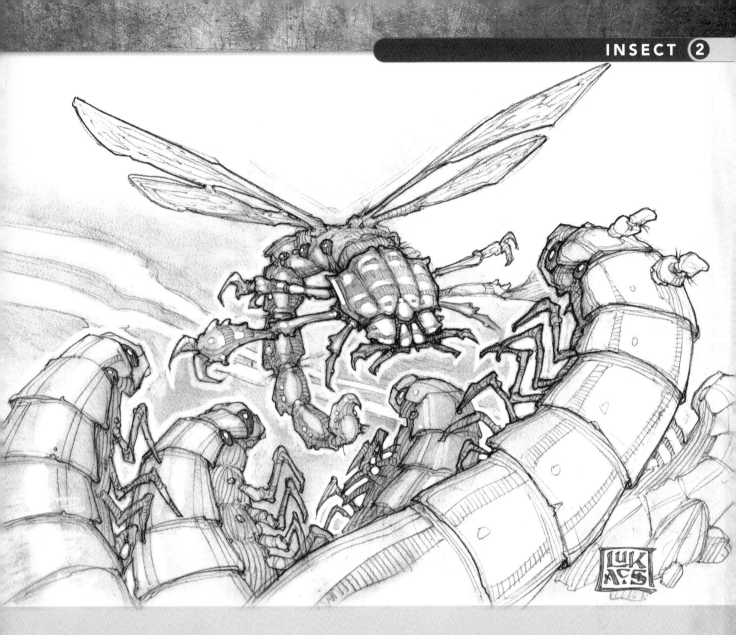

2 Insect :: 2d6

In the Insect roll lie the smallest and most adaptable inhabitants of the Anima kingdom. Most insects live next to us, walking about on multiple sets of legs. Their skeletons are external cases, making limbs like the sharpest weapons and body segments like armor plating.

Despite their size, insects bring out the whole range of emotions in humans. This is why they can be so useful to the creative fantasy geneticist. They live in cocoons and hives, they bite and sting us, they can lay eggs as parasites, and they can poison us. They can be as bothersome as a fly, as elegant as a luna moth, or as revered as the scarab. Their eyes can be cold and evil like spiders', or cute and childlike like a ladybug. Most important, insects give us the opportunity to play with size. The fact that insects invoke all this emotion in us means that scaling them up to mammalian size scales up the emotional response to your creation.

②

INSECT LIST
2d6 Roll

 2 Worm
 3 Ant
 4 Mosquito
 5 Moth, Butterfly
 6 Fly, Dragonfly
 7 Lotus, Mantis
 8 Bee, Wasp
 9 Caterpillar
10 Beetle, Scarab
11 Flea, Mite
12 Spider

BODIES AND LEGS: SPIDER

Here we study just what those creepy crawly things use to creep and crawl. Insect legs and bodies haven't changed much over the ages; they are perfectly suited to their purposes: lifting, climbing, running, cutting, digging. Many insects are so strong that they can fulfill their function around ten times more efficiently than the rest of our animal kingdom. We'll begin with a thick, hairy spider leg. Pay close attention to how thick or thin the different types of insect legs are, as well as their function, how many can be placed next to each other, and where on the body a leg or set of legs might look believable on a concept of your own. A spider is actually an arachnid, not an insect, but insects of all types are similarly segmented and symmetrical, so you'll be able to apply what you learn drawing the spider to many other creatures.

2 INSECT LIST
2d6 Roll

2 Worm
3 Ant
4 Mosquito
5 Moth, Butterfly
6 Fly, Dragonfly
7 Lotus, Mantis
8 Bee, Wasp
9 Caterpillar
10 Beetle, Scarab
11 Flea, Mite
12 Spider

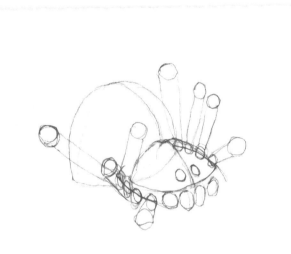

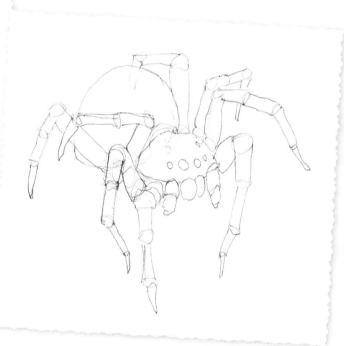

SKETCHING THE BASIC SHAPES
Sketch in the two major body parts: the head with fangs and the abdomen. Run a centerline along each. Even though you don't see the belly or thorax of this spider, add the starting points of each of the eight legs around each side between the head and abdomen. Add each "knuckle" to show the gesture of each leg, and connect them to make the first segments of the legs.

2 TIGHTENING THE LEGS
Erase and tighten the shapes of the face and fangs. Most insect legs should be treated like fingers, graceful and agile. Extend the lower parts of each leg giving them three segments from the "knuckle." I will sometimes treat the last "fingernail" as two parts to add more gesture. Play around with the gesture of each leg, thinking about how much pressure the spider might be putting on this one or that one, or if the leg is just curled up at rest.

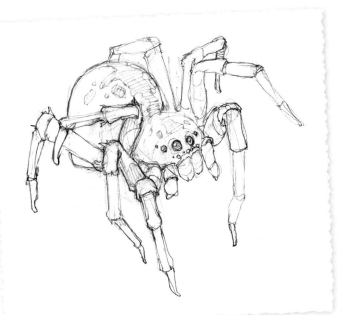

3 FINALIZING THE SHAPES

Draw in the pattern running along the centerline of both the head and abdomen. Start to form the final shapes of each leg; draw tiny clumps of hair at the "knuckles," and make each leg taper off to a thin, gentle nail.

4 FINISHING THE DETAILS

Finish adding shadows inside the spider's pattern, underneath its abdomen and under the bottom portion of each leg segment. This will give the legs more contrast to show through. Erase your guidelines, and darken the outlines that define each leg and each major form. Add details such as tiny hairs along the legs, and pull out the highlights on each of its eyes.

SEGMENTED LEGS = FINGERS

Think about segmented legs like fingers. You can act out how each one will move and stand simply by testing how your finger does the same movement.

BODIES AND LEGS: CATERPILLAR

The body of a stumpy caterpillar is segmented and long. Remove the tiny legs and you have the basic form of a worm. Worms are not technically insects, as in part of the class Insecta. The term "worm" generally applies to an invertebrate animal. And the worms we generally think of are divided into several different classes within the phylum Annelida. Here we will study both worm and caterpillar body and leg forms as they bend, move and grip.

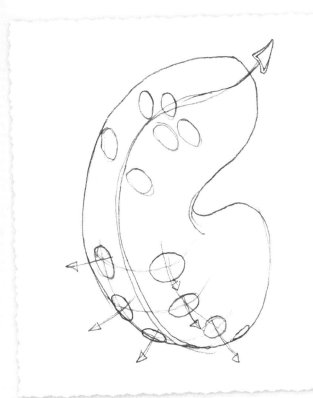

SKETCHING THE GUIDELINES
Draw the twisted worm body, and run an equally twisted centerline along the belly. This line sits on the very center of the worm's belly and will show the worm's gesture and arch. Then plot the spots where each of the legs will spring out.

REPETITION AND INSECTS

Repetition is very important to the look of insects. The segments of the body, the number of wings and the spaces that separate the veins of the wings all attract our eyes. This repetition means insect forms can also work as mechanical concepts or creatures.

2 **BEGINNING DETAIL**
Sketch in the eyes and face. Keeping inside the form of the body, add the circle segments from head to tail. Draw in the twig it is eating, and add the pincer legs to grip the twig. Erase the centerline. Then extend the six walking legs from the body.

FOLLOW WHAT YOU SEE

Did you notice how the twig that our caterpillar is eating looks like a saxophone? Go ahead and sketch it in. Don't pass up a chance to play with what looks interesting even if you didn't roll anything like it, and remember to look at everything with no rules attached!

3 ADDING MORE DETAILS

Start forming the outlines around each circular body segment, and define the wrinkles of the pincer legs and claws as they grip the twig. Keep the sketch loose and create more detail and wrinkles to the skin of the body. Make it droop and sag on top like a fabric sack by adding darker shadows in the wrinkle creases, and then smooth out your lines as you go down the body to make it plump. Separate the lower walking legs into round, thick segments, flaring each leg at the end with a suction-cup shape.

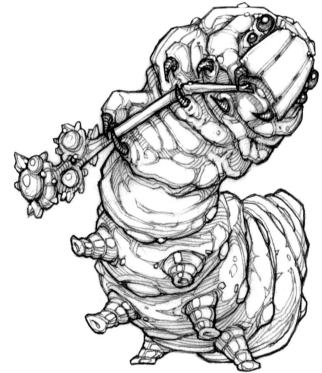

4 FINISHING

Darken the outlines to define the forms. Add in the end of the twig and the shadows underneath each segment of skin. Put in more shadows down the belly toward the tail of the body. Erase any guidelines and tighten up the details around the legs. Make sure each leg is the same size and uniform in shape.

WINGS: MOTHS AND BUTTERFLIES

We watch them gliding through wild fields or hovering and collecting nectar for the hive. We find them on the shoulders of fairies and forest nymphs and on the backs of devils and demons. Insects have amazing wings. They can be feather light, floating on a hint of air, or rigid like an exoskeleton, buzzing a tune through the night. The patterns on insects can look like the patterns on seashells and reptile skin. I think they can even look like the beautiful forms that you see in a lava lamp. In this demonstration, you will learn how to construct a pair of butterfly wings. Try attaching insect wings on as many different concepts and creations as you can.

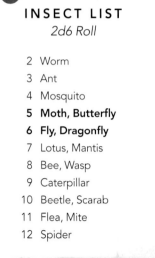

2

INSECT LIST
2d6 Roll

 2 Worm
 3 Ant
 4 Mosquito
 5 Moth, Butterfly
 6 Fly, Dragonfly
 7 Lotus, Mantis
 8 Bee, Wasp
 9 Caterpillar
10 Beetle, Scarab
11 Flea, Mite
12 Spider

Insect Wings Vary

Here we see two of the many different forms of insect wings: a dragonfly (top) and a ladybird beetle (bottom). The beetle's wings are kept folded underneath its protective shell when not in use. Structural veins run across the whole length of each wing. Notice how the dragonfly's vein pattern is more complex and that the markings follow the directions of that vein pattern.

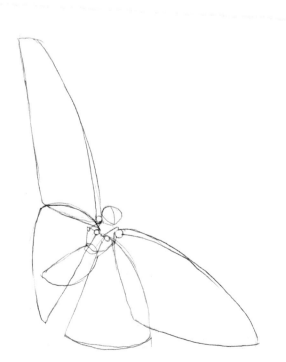

SKETCHING THE BASIC FORMS

Roughly sketch the three main parts of the body of the butterfly: the head, thorax and abdomen. Then place both the upper and lower wing guidelines on either side of the thorax. Make the length and width of each wing symmetrical in shape and position to the thorax where they connect. Don't be afraid to erase or draw through the body to get the position right.

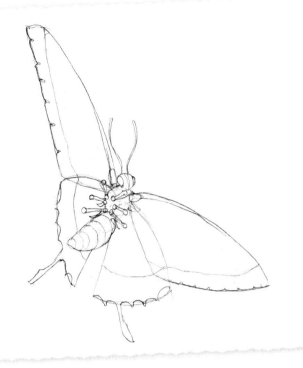

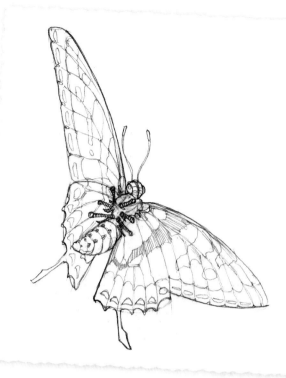

2 BEGINNING DETAIL

Sketch in eyes and antennae on either side of the centerline of the head. Draw in the legs, fanning them out from the connecting points on the thorax. Place circle guidelines along the abdomen, breaking it into equal sections. Then draw in the guideline bands along the bottoms of both upper and lower wings, and start to break up those bands into segments. This is where the veins of the wing will connect; they should be evenly spaced along the edge of each wing.

3 REFINING OUTLINES

Erase the guidelines and darken in the shapes of the legs and eyes. Lightly sketch in the vein pattern on each wing, connecting the ends of the veins to the segments you've evenly spaced out. Then lightly map out where the black markings of your butterfly will flow over the veins. Placing pattern is my favorite part of most creatures, but it's a good idea to wait until the end to start sketching any pattern over the forms you've made. Notice that the markings flow right over the upper and lower wings, even though they are completely different objects, making them look like one wing.

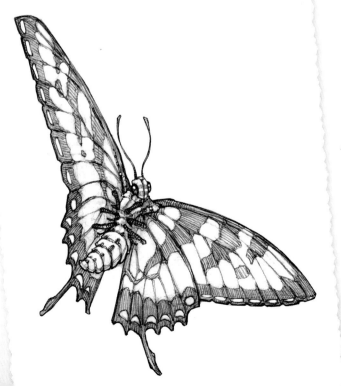

4 FINISHING

Sketch the shadow areas underneath the forms of the body and fill in all the detailed black markings across the wings. I like to sketch out my shadow hatching on the wings in the direction that the wing forms from shoulder to tip. This way the linework tends to radiate out from the body no matter where the wings are positioned. Lightly smudge the pattern areas to make a more even tone, then erase the highlights of the body and the segments of the wings.

3 and 6 Mammal :: 1d6

Welcome to the menagerie of mammals, fantasy geneticist! Here we will find that the body forms and evolutionary distinguishers of mammals differ as much as an elephant differs from a monkey or a mouse. Mammals are split into two separate lists, and their body forms supply an endless potential of sizes and anatomical structures.

3

MAMMAL LIST
1d6 Roll

1 Sheep, Cow
2 Mouse, Rabbit
3 Pig, Boar
4 Deer, Pronghorn
5 Ram, Bull, Buck
6 Elephant, Giraffe

6

MAMMAL LIST
1d6 Roll

1 Bat
2 Bear
3 Lupine – Wild Dog
4 Horse, Zebra
5 Feline – Wild Cat
6 Primate

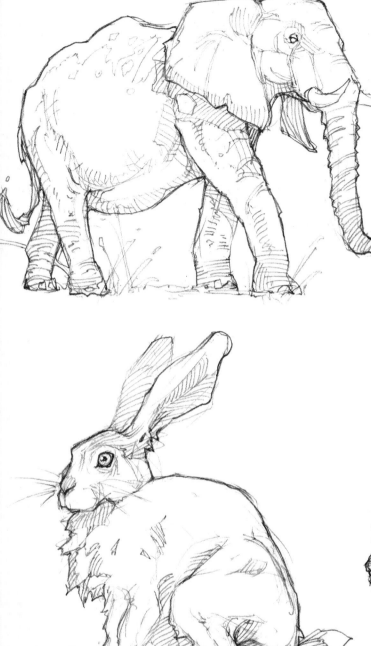

Mini Hybrid Game

Practice the mammal natural forms, or mix it up with this simple mini hybrid game to make it more interesting.

 1 Roll the 3 Mammal List
 2 Roll the 6 Mammal List

Pick a torso and body form from one roll, and use the other roll for your hybrid mammal's legs or head. Have fun mixing and matching parts, and use the best combinations for future fantasy creations.

HORNS AND ANTLERS: RAM AND DEER

Horns are bonelike projections from the skulls of some mammals; males use them as weapons and tools in the wild. They grow much in the same way that shells do, developing ridges and warts along old growth as the animal gets bigger. They come in a dizzying variety of shapes and forms, and are one of the best ways to make any character's head more interesting. They can make a character look more evil or just more natural. Satyrs, faeries, unicorns, druids, demons and devils have all been illustrated with horns, thus horns can become symbolic of danger, power and leadership. The example here shapes together the horns of a ram and a deer, with some weird positioning mixed in for fun.

> **3**
> ## MAMMAL LIST
> *1d6 Roll*
>
> 1 Sheep, Cow
> 2 Mouse, Rabbit
> 3 Pig, Boar
> **4 Deer, Pronghorn**
> **5 Ram, Bull, Buck**
> 6 Elephant, Giraffe

Horn Shapes

Think of horns as hollow tubes: square, circular or triangular.

SKETCHING

Map the features of the head and draw a centerline from the nose to the point of the head. Place the bases of the horns on either side of this centerline or right along the center of the skull. The ram horns are formed as spirals like a shell by adding perspective guidelines along the whole length. The deer antlers are formed somewhat like the trunk of a tree, branching off into smaller, asymmetrical horns as you get to the tips.

2 ADD DETAILS

Add more shape to the ram horns, and keep in mind their perspective as you sketch in the ridge details and wrinkles along the perspective guidelines. Form the fingerlike deer antlers both on top and those that branch out downwards from the jawline. Also add the little nub projections that spot the snout. Erase the guidelines you don't need and darken the outlines.

3 FINISHING

The light source falls almost directly above, so shadows fall directly beneath the forms. For the deer antlers, add tiny wart shapes at the base and directional marks to indicate cracking and wear. For the ram horns, darken in the creases and ridges, making them more rounded, and erase out the spots of direct highlight.

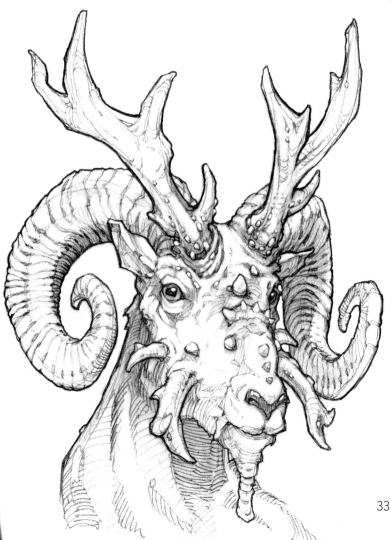

LEGS: RABBIT AND RODENT

Like the legs of the canine (or lupine) and feline (see page 41), rabbit and rodent legs fall into the category of the *digitigrade*. They walk with their fingers or digits on the ground. Rabbit legs are perfectly suited for their functions: wide enough paws to burrow into the ground, lightweight and strong enough to flee from their predators' attacks. Notice that the hind rabbit leg that we will sketch has large upper leg muscles and smaller muscles and tendons as you get farther down to the paws. With this leg, you'll have your fantasy concept hopping and burrowing in no time.

③

MAMMAL LIST
1d6 Roll

1 Sheep, Cow
2 **Mouse, Rabbit**
3 Pig, Boar
4 Deer, Pronghorn
5 Ram, Bull, Buck
6 Elephant, Giraffe

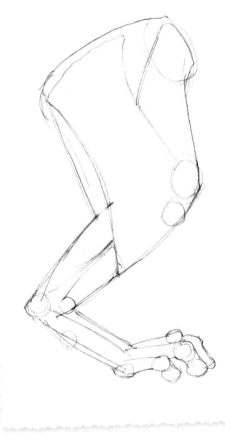

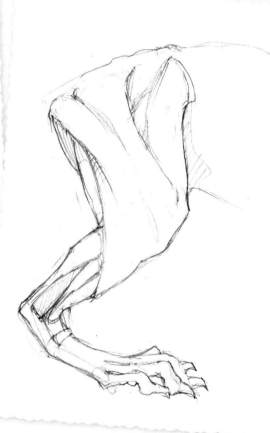

❘ SKETCHING MUSCLES AND ❘ JOINTS

Roughly sketch the shapes of the muscles, circling the points where the muscles connect to the joints. Sketch in those same joints on the paw, and connect them with rough lines for each finger. Erase the muscle guidelines where muscles overlap each other.

2 BUILDING UP THE MUSCLE ANATOMY

Start sketching in details to all the muscle shapes. Erase the basic outline as you smooth the shapes of the muscles. Taper each lower leg muscle as it connects to the joints, forming blocks of shadow where the upper leg muscles overlap the lower muscles. Each gap between muscles forms pockets that will also make a shadow on the surface of the skin. Draw these pocket shapes and add the claws and pads that lie underneath them. You should have the basic muscle anatomy that lies beneath the skin.

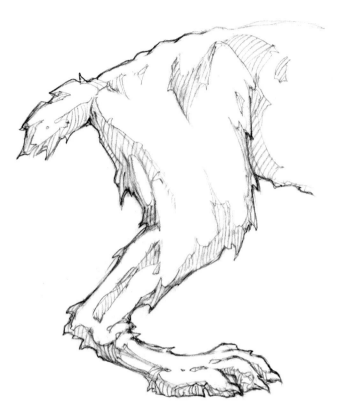

3 FINISHING

Cover these muscles with skin by erasing the detail of the muscles, smoothing and combining the shadow shapes, and sketching in tight skin wrinkles where the joints bend. Sketch in fur by erasing sections of the outline. Add a tail and clumps of fur that extend past the muscle outlines. Fur will normally spread out and bunch up at bent joints. Sketch the shapes of shadow that form underneath the paws and inside the pockets between muscles. Then fill those shapes in with shadow tone. Erase any guidelines and tighten the fur outlines. Then your rabbit leg is ready to spring into action!

Rabbit at Rest

The hind legs are compressed in the resting position. Notice how the leg gets plumper when the muscles aren't in use. If the fur were a bit thicker, you might not see any surface anatomy, only a couple shapes to define the paw and major shapes of the leg.

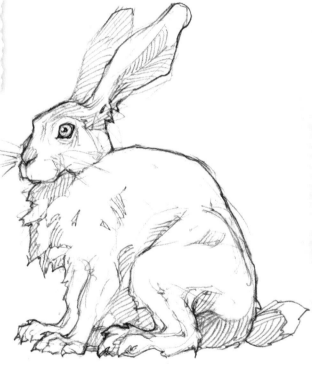

Drawing Fur

Fur is best defined by its shadows. Here, each clump juts out from the center of the circle, and the shadow defines the shape of each clump. This guy's white fur is shorter on top and thicker at the bottom, so there are small shadows on top and larger ones on the bottom.

LEGS: HORSE

From the caves of Lascaux to Da Vinci's twenty-four-foot horse sculpture to Fuseli's *The Nightmare* and the countless portraits of famous steeds led to battle, the horse and its forms have been part of human art and culture since days untold. They are our religious deities, our mystical centaur and Pegasus, our derby sports heroes and our domesticated pets. Horse legs are very similar to the legs of most herd mammals that you might roll in the Mammal Lists: sheep, bulls, boars, deer and giraffes. They fall into the category of *unguligrade*, as they have one hoof per leg, and they walk or run on the flat sole of that hoof. In this demonstration we will cover some basic muscle anatomy and how to make those muscles form believable legs for your creations. This could be one of the most helpful things you learn about making believable animal concepts and creations.

3

MAMMAL LIST
1d6 Roll

1 **Sheep, Cow**
2 Mouse, Rabbit
3 **Pig, Boar**
4 **Deer, Pronghorn**
5 **Ram, Bull, Buck**
6 **Elephant, Giraffe**

6

MAMMAL LIST
1d6 Roll

1 Bat
2 Bear
3 Lupine – Wild Dog
4 **Horse, Zebra**
5 Feline – Wild Cat
6 Primate

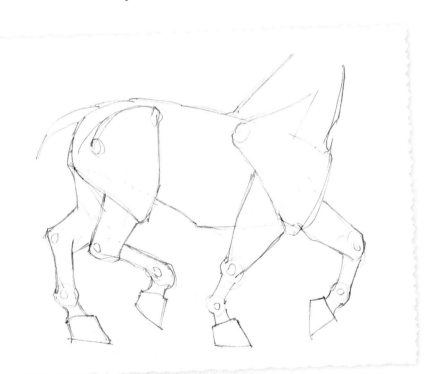

SKETCHING THE BODY SHAPES
Roughly sketch out the major body shapes, circling the points where the muscles connect to the joints. Place the major muscle sections of the legs themselves on the body, again circling the connecting joints and measuring with your pencil to make sure the proportions between the joints are the same distance. Don't be afraid to erase at this point, as mistakes made in the beginning of a sketch will often make their way to a final concept if you're not careful. Then sketch in the shapes of each hoof onto the lower legs. The hooves that are raised bend a fair amount inward, and the planted hooves tend to bend slightly outward.

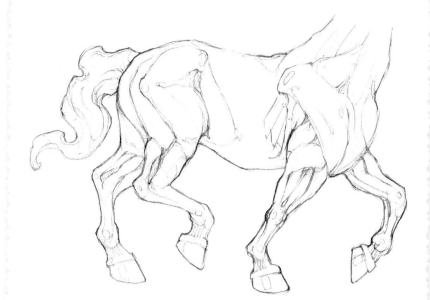

2 DEFINING THE LEG MUSCLES

Take a section of each leg, and begin defining the outlines of each muscle within that group. Connect the muscles to each joint along the leg, and erase the basic shapes, rounding out each muscle to make more complex shapes inside. The muscles of the planted legs are thinner because they are extended, and the muscles of the raised legs are plumper because they are compressed. Darken the gaps between muscles with shadow.

3 FINISHING

Keep in mind that you are wrapping skin over the muscle structure you've built up. Sketch in the skin wrinkles at the bent joints, and add a tail and hair along the backs of the hooves. Block out the shadow areas that define each leg muscle. Erase the outlines of the muscle shapes where the skin smooths them out. Then replace those outlines with the shadow shapes underneath the main body and each leg muscle, and fill them in with shadow tone. Finish by darkening the outlines and adding highlights to the center of each hoof.

TEETH AND TUSKS

We use them to eat, to bite; we can bare them in both a smile and to show anger and aggression. Symbols of strength and social class, they are saved in religious relics and stashed underneath our pillows when we're young. Teeth are the pointed canines that predators attack and tear with, and the long spears that defend against those attacks. Teeth are also the flattened molars that herd mammals use to grind and pulp food. Here, you'll learn how to draw these different styles of mammal teeth to give your concepts and creations a little bite!

3
MAMMAL LIST
1d6 Roll

1 Sheep, Cow
2 Mouse, Rabbit
3 Pig, Boar
4 Deer, Pronghorn
5 Ram, Bull, Buck
6 Elephant, Giraffe

6
MAMMAL LIST
1d6 Roll

1 Bat
2 Bear
3 Lupine – Wild Dog
4 Horse, Zebra
5 Feline – Wild Cat
6 Primate

SKETCHING GUIDELINES

Roughly sketch the clamshell guidelines that define the shape of the jaws and the top of the head. Then split the whole head with a centerline that divides the face and jaw. Draw guidelines for the upper and lower lines of teeth and their gum lines, then the spots where your outermost teeth and tusks will jut out from.

2 SKETCHING THE BASIC SHAPES

Draw a basic placement of the nostrils, eyes and tongue. Then begin to sketch the shapes of each set of teeth, paying attention to the centerline to place them equal distance apart. Remember to draw through and over the shapes to get a good idea of where to place the teeth. Start sketching in the basic shapes of the teeth; the canines and tusks should taper to points.

Tusks

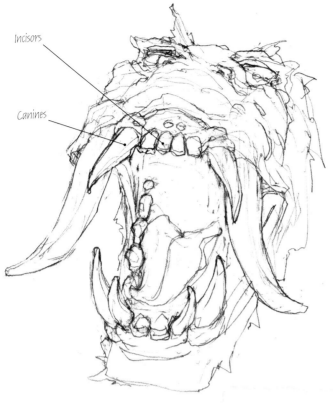

Incisors

Canines

3 BEGINNING DETAILS
Start to add more detail to each tooth. Use the jawline to place the box-shaped molars, and the upper and lower gum guidelines to place the incisors. Draw in the gums around each tooth, thinking of them as little caps of skin that surround the teeth all in a row.

4 FINISHING
Darken the gum lines and the outlines of each tooth. Teeth are generally white against the dark of the mouth, so add shading to the back of the mouth and lightly rub your finger along each tooth to add a bit of shading. Then with a sharp piece of eraser, rub out highlights in the center of each tooth and on the gums. This makes the teeth look wet and glossy.

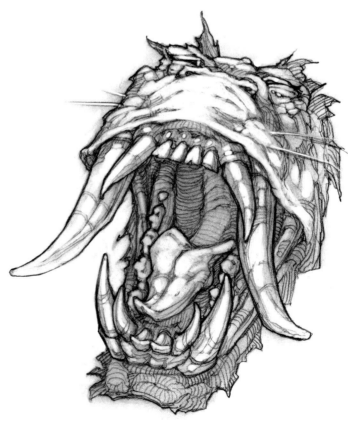

PAWS AND CLAWS: MICE AND RODENTS

Paws are essentially the hands of mammals, some as graceful as the human hand and others as rudimentary as hooves. In this demonstration, you'll learn to draw the paw of a tiny mouse, which, with the exception of our opposable thumb, is quite like our own hand.

<table>
<tr><td colspan="2">3</td></tr>
<tr><td colspan="2">MAMMAL LIST
1d6 Roll</td></tr>
<tr><td>1</td><td>Sheep, Cow</td></tr>
<tr><td>2</td><td>Mouse, Rabbit</td></tr>
<tr><td>3</td><td>Pig, Boar</td></tr>
<tr><td>4</td><td>Deer, Pronghorn</td></tr>
<tr><td>5</td><td>Ram, Bull, Buck</td></tr>
<tr><td>6</td><td>Elephant, Giraffe</td></tr>
</table>

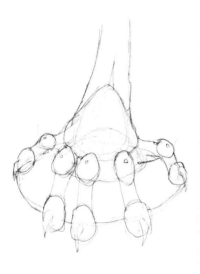

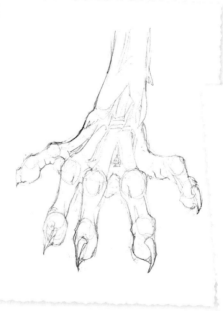

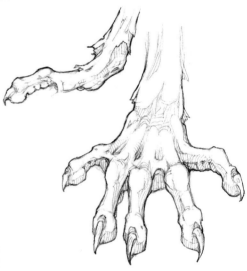

1 SKETCHING THE BASIC SHAPES

Draw a half-circle guideline that puts the paw on the ground, then a guideline for the knuckles above. Map out the shape of the wrist, and connect it to the arm shape. Most wrists connect to two bones—the radius and ulna—that twist the wrist from side to side. Roughly sketch in the five circles of the finger pads and the claws along the bottom guideline. Then sketch the circles that will become the knuckles along the top guideline around the wrist. Connect each of the fingers between the wrist and knuckles and between the knuckles and pads.

2 BEGINNING DETAIL

Sketch more hair detail on the wrist, the bones that extend out to each knuckle, and the shadows between each one. Erase guidelines and begin shaping each knuckle and claw. Add more surface detail to the skin, wrapping and wrinkling around the bones. Claws attach to the tops of the bottom knuckles with pads that rest below on the ground, and the skin between the top knuckles forms a slight web between each knuckle.

3 FINISHING

Erase highlights on the top of each knuckle, claw and bone. Darken the outlines around each finger and claw, and put in some hairs along where the knuckles bend. Then add in the final skin wrinkles and shadows below the pads.

PAWS AND CLAWS: DOGS AND CATS

Now you'll create the paws of a lion. They are shorter than mouse paws, but a lot like the paws of wolves and dogs in that the four main fingers have longer anatomy so that they can extend their claws out much farther in attack. Another difference is that on this paw, the smallest "pinky" claw is set far up on the wrist instead of in line with the others. The lion paw can be used to show that your creation is a predator or hunter.

6

MAMMAL LIST
1d6 Roll

1 Bat
2 Bear
3 Lupine – Wild Dog
4 Horse, Zebra
5 Feline – Wild Cat
6 Primate

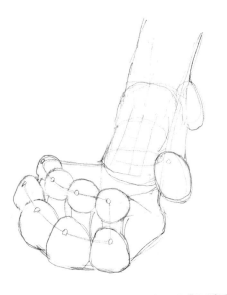

SKETCHING THE BASIC SHAPES
Roughly sketch a basic cube that is rounded in the front. Add upper and lower guidelines and the circles along both guidelines that will form knuckles. Roughly sketch the arm and connecting bone shapes. Notice the *ellipses* (see page 58) you sketch into the wrist; they will eventually be the bands that hold the wrist muscles in place underneath the skin.

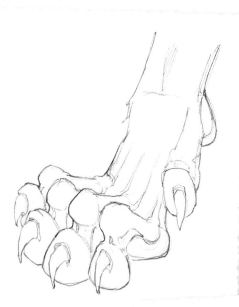

2 BEGINNING DETAILS
Slowly erase the guidelines as you form the shapes of the knuckles and bones that connect them. Attach the claws to the tops of the knuckles, and sketch wide pads underneath each one. Then begin some of the skin wrinkles where the joints of the knuckles bend.

3 FINISHING
Add the shadows underneath each pad and knuckle. The bands that wrap around and between the bones along the wrist break up the shadows. Erase the highlights on the tops of the major forms, and add the last details of skin wrinkles and hair that form from the bended knuckle joints.

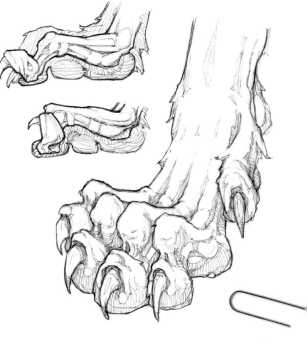

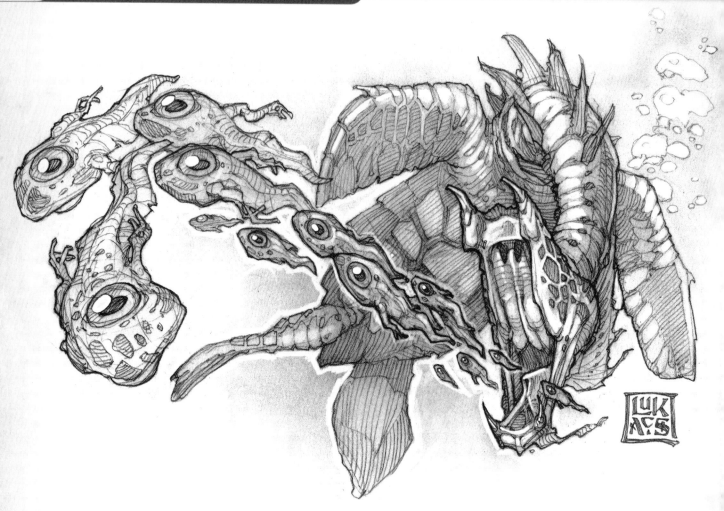

4 Reptile :: 1d4

They are the planet's frogs, geckos, snakes, lizards and crocodiles. These amazingly diverse creatures can live both on the ground and in the water, and the bodies, limbs, eyes and ears of amphibians and reptiles are shaped to suit both habitats. They have incredibly strong genetics; some track fossils exist dating them back 300 million years. They're cold-blooded, egg-laying and covered with beautifully patterned scales. In fact, when you get a Reptile roll, you may not need to look further than adding the pattern of a gecko or turtle shell. The myriad forms and actions of reptiles shouldn't be overlooked either: spitting cobras, long attacking tongues, spiked crests, gliding fins, coiled tails, plated bellies, dewlaps and all their historical dinosaur counterparts.

4

REPTILE LIST
1d4 Roll

1 Crocodile, Gila
2 Frog, Newt
3 Lizard, Snake
4 Turtle

LEGS: AMPHIBIANS AND REPTILES

Here we see an odd reptilian mutant concept to show a variety of both amphibian and reptile legs. He has the webbed toes of both toad and frog on the left, and the clawed and thick-scaled limbs of a turtle on the right. In this demo you'll learn the skills to make your Reptile rolls crawl and swim about, with both soft slimy toes and rough sharp claws. Don't forget to experiment with lengths and sizes to make your creations even more interesting.

④

REPTILE LIST
1d4 Roll

1 Crocodile, Gila
2 Frog, Newt
3 Lizard, Snake
4 Turtle

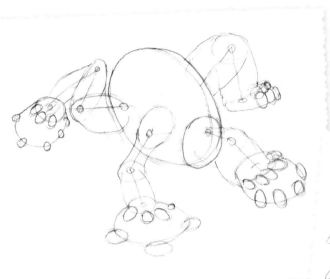

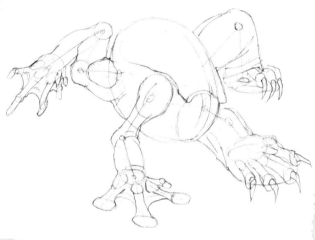

SKETCHING THE BASIC SHAPES
Lightly sketch the main egg-shaped body and the points and centerlines for all four legs as they spread out from the main body. At the ends of the legs, draw in the disk shapes that will become the feet, then the knuckles and finger points around the disks.

2 **BEGINNING DETAIL**
Begin detailing each pair of legs and their knuckles and fingers. The turtle legs are bulkier, and, since the knuckles have claws, they are taller and thinner. As you sketch the main shapes of the frog legs, notice that the finger shapes are thinner on the hind legs, the disk shapes are wider in front, and thin webs curve between each finger. Draw in the ridge shapes for the mutant's soft shell, adding a centerline down the top of the egg body for the pattern to flow.

3 REFINING THE FEATURES

Erase the main guidelines as you sketch more details into the legs. Lightly sketch in the scales of the turtle legs with deep wrinkles and bumps. Give the frog legs round wrinkles in the smooth skin. Also add in the pattern lines that stretch over the soft shell and the wet highlights that will pop through that pattern. Refine and darken the outlines around the major shapes, and add the shadow areas underneath each major form.

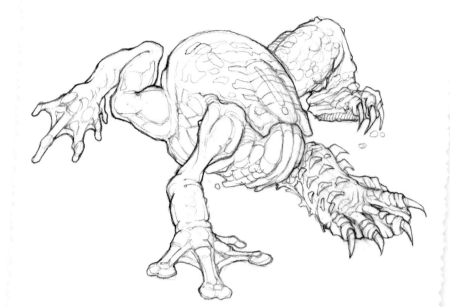

4 FINISHING

Lightly rub in tone to the shadow areas and pattern, hatching in lines to darken them further. Pay special attention to the ridge of the shell and how the shadow curves over the different wrinkles and forms, tying them to the body. Erase out the highlights that have muddied over, further bringing out the wrinkles and forms of your mutant.

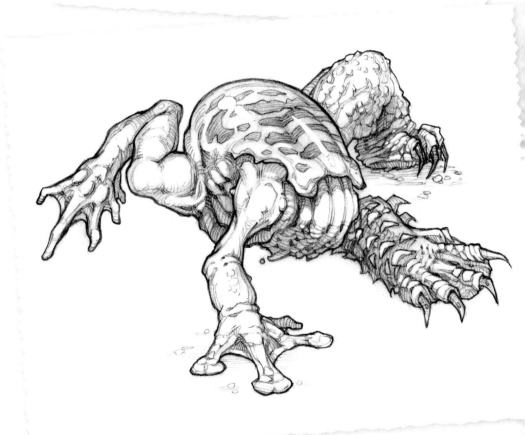

JAWS: CROCODILE

The first images that come to mind when I get a crocodile or any reptile roll are the goliath creatures of our ancient history: dinosaurs. Whether herbivores or carnivores, most reptiles have an ancient dinosaur counterpart at least ten times their size with protective scales and massive crushing jaws. The most beautiful and believable dragons will also be made with parts both ancient and modern. A creative fantasy geneticist will mix different anatomies and look for picture reference of both modern reptiles and dinosaur skeletons.

This demonstration will cover the basic forms and patterns of a crocodile's jaw, scales and back plates. The forms of a modern crocodile can give you the basis for many fantasy creatures. Having them in your bag of tricks will give any of your creations that fierce prehistoric feel.

REPTILE LIST
1d4 Roll

1 **Crocodile, Gila**
2 Frog, Newt
3 Lizard, Snake
4 Turtle

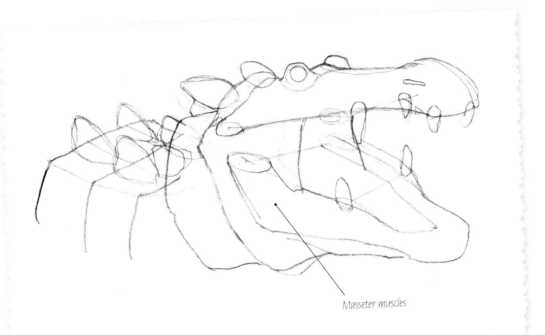

Masseter muscles

SKETCHING THE BASIC SHAPES
Lightly sketch in the main shapes of the anatomy of the jaws: the upper and lower palates, the masseter muscles that connect the two, and the guidelines for the wrinkled neck cowl and back plates. Then draw guidelines for the biggest pairs of teeth along the jaws, and place those teeth, making sure they will be in a position to interlock when the jaws bite down. Sketch the brow guidelines and eyes, and the guidelines and shapes that will form the spikes that run along the back plates.

2 BEGINNING DETAILS

Erase some of the guidelines, then form the secondary shapes of the jaw. Notice the evenly spaced pockets around all the teeth, how the teeth follow along the curved jawline and how they will fit together when the jaws are snapped shut. Refine and darken the outlines for each major secondary shape. Break up the neck cowl into guidelines for scales to run along. Add more details to the nostril, eye sockets and masseter skin, and lightly wrap the pattern shapes under the bottom jaw.

3 BEGINNING SHADOWS

Break each guideline of the neck cowl into individual scale shapes, and erase the original guidelines completely as you darken and refine the outlines of each scale. Then begin lightly mapping the shadows of the inner mouth, the masseter skin and along the rest of the jaws and body. Sometimes I first draw in and darken with tone the major shapes of a pattern, then break them up into individual and random scales. Notice how the scales get smaller and pointier as they get closer to the moving skin of the jaw, and thicker and larger when they are covering bone.

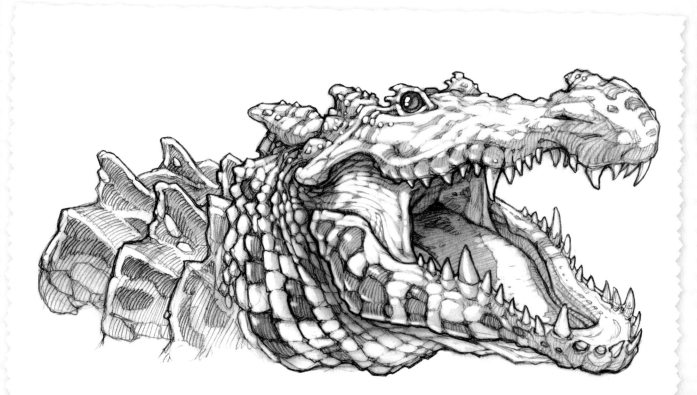

4 FINISHING

Fill in the warts and details of each tooth and scale. Thicken the outlines at the joints of skin and scales to reinforce the original shapes. Then rub and sketch in the shadow areas, erasing out any spot highlights and guidelines that remain. Repetition and contrast of the highlights on teeth and scales will make the crocodile look shiny and wet.

EYES CAN SHOW STRENGTH

Notice that many dinosaurs and ancient creatures have much broader brow lines and smaller eyeballs. When designing a concept that should look strong and prehistoric, making the eyes smaller than normal always helps. Many animals show fear of attack by smiling with wide eyes, so you can also make any massive creature look more ferocious by widening the mouth and eyelids all the way open.

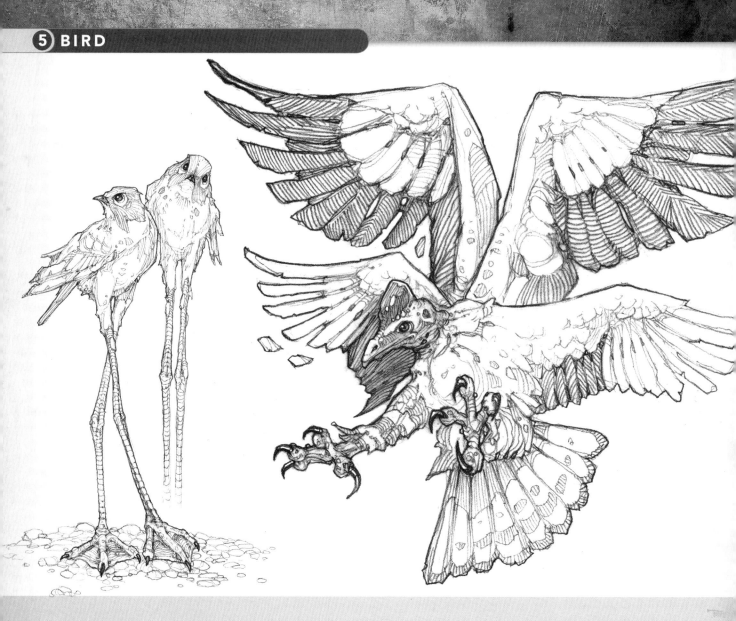

5 Bird :: 1d6

Look across the morning skyline from anywhere, and you'll find flocks of birds feeding, bathing and taking to the air. Their elegant winged forms soar the airways, populate city parks and swim arctic waters. Over the centuries they have found waterways in drought, saved our lives in the depths of toxic mine shafts, been kept as pets that mimic our speech, been hunted as game and been worshipped as deities of the sky. And they inspire us as they point their feathers into the wind in migratory flight.

BIRD LIST
1d6 Roll

1 Wild Fowl, Duck
2 Farm Fowl, Rooster
3 Seabird, Penguin
4 City – Raven, Sparrow
5 Tropical – Parrot, Heron
6 Bird of Prey – Hawk, Owl

FEATHERS AND WINGS

Feathers and wings make a bird a bird, but they can be used in all manner of creations. There are countless bird deities and feathered manifestations warning "Nevermore" in our cultural histories. From angels to Hermes, the many winged forms throughout world mythology can be used when you roll the Bird List. In this demonstration you'll learn the basic forms of wing and feather construction to incorporate in your creations.

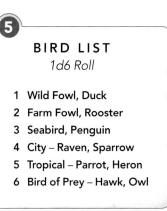

⑤

BIRD LIST
1d6 Roll

1 Wild Fowl, Duck
2 Farm Fowl, Rooster
3 Seabird, Penguin
4 City – Raven, Sparrow
5 Tropical – Parrot, Heron
6 Bird of Prey – Hawk, Owl

SKETCHING THE GUIDELINES

Draw triangle shapes that attach to the bird's body. Add circle points for the knuckle joints where both wing shapes join. Then draw guidelines for both wing shapes, and break each shape into two rows of feathers. The bottom row should be longer than the top row. Make sure each wing part is close to the same length and position at this point. Where you place the wings on your creation is less important than that they are symmetrical.

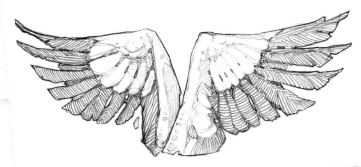

2 BUILDING THE FEATHER SHAPES

Lightly sketch the two rows of feathers by breaking the wings into equally-spaced feather shapes along the guidelines. All the feathers point toward the knuckle joints and become more flared with wider gaps between as they spread to the bottom row. Cap off the top row of feathers with tiny staggered feathers that look something like fish scales. The feathers become smaller the closer you get to the knuckle joint of the wing. Check for symmetry in each wing, darken the outline and map out the shadow areas underneath each feather.

3 FINISHING

Add contrast using both shading and multidirectional hatch lines. Darken the bottom row of feathers with tone and directional hatch lines. Notice how the different-directioned hatch lines affect the movement of the wing. A series of gap shapes in the feathers will accent the repetition of the wings. Add details such as rips in individual feathers, then erase any guidelines and highlights.

BEAKS AND BILLS

Every bird beak cracks through an egg as a newborn, and all birds have evolved perfectly to fit their habitat and food supply. An Amazonian parrot's beak is wickedly strong and can hold and crack nuts, the softer spoon-billed stork sifts through shallow waters for tiny fish, and the beak of an eagle or owl is sharp and hooked to tear into its prey. In this demonstration we will mix these three bird beaks together into one bizarre squawking mutant to show you how a good dose of beak or bill might fit into any Bird roll for your fantasy creations.

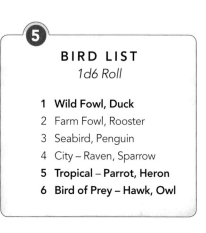

5

BIRD LIST
1d6 Roll

1 **Wild Fowl, Duck**
2 Farm Fowl, Rooster
3 Seabird, Penguin
4 City – Raven, Sparrow
5 **Tropical – Parrot, Heron**
6 **Bird of Prey – Hawk, Owl**

SKETCHING THE GUIDELINES AND SHAPES

Lay down the central head shapes and vertical guidelines that each beak will be drawn along, and indicate the hinge where the upper and lower parts of each beak will fit together. Then lightly sketch in the basic guideline shapes that form the parts to each beak. Notice the differences in all three as you draw: the parrot beak has an overbite and has two similar shapes that face different directions; the spoonbill has an ellipse at the end of two shapes the same length that fit together exactly; and the owl beak has a slight overbite, drawn with similar shapes facing the same direction. Draw in a guideline for the brow ridges on each beak.

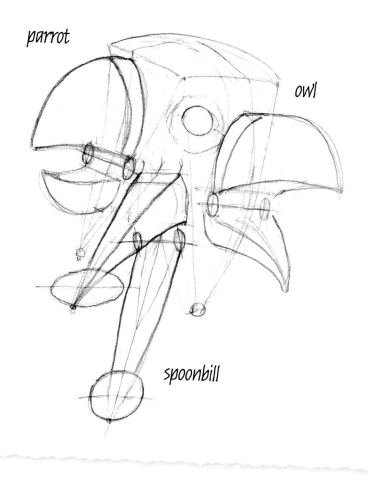

parrot

owl

spoonbill

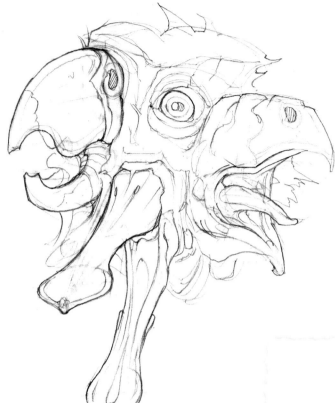

2 BEGINNING DETAIL

Sketch in the secondary shapes within the basic shapes, erasing the guidelines and hinges as you outline more detail into each beak. Pay special attention to how both parts will fit together as they close, the direction in which the two tongues jut out and where each beak's nostril holes are placed. The connecting skin wraps over the upper and lower parts of each beak in different ways; draw the outlines of those wrinkles and ridges into the forms of each beak and bill.

3 FINISHING

Add the details that make each beak different. The parrot beak is rounded, but has deep angular wrinkles drawn into the connecting tissue and brow ridge, and it gets darker toward the tip. The spoonbill is smoother and softer, with wart shapes drawn along the edges that its teeth close in to. The owl beak is drawn with sharp angles and smoother, thinner connecting skin.

Sketch in the shadow areas of every beak, making the nostrils and the inside of each beak the darkest. Also hatch tiny shadows near the brow ridges to show where the hard surface of the beak meets the soft-feathered brow. Darken and detail your outlines, and erase any muddy highlight areas.

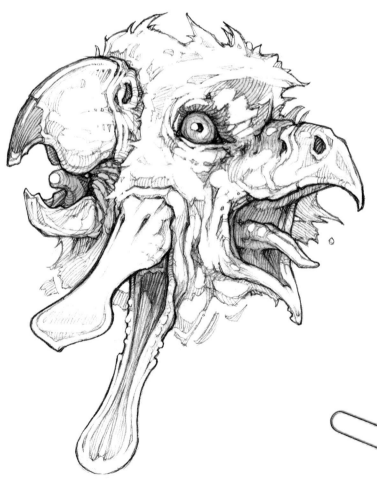

TALONS

Birds of prey have just the right equipment to hunt the land, air and water. Their razor-sharp talons can nab a rodent from its hole or snare a fish straight from the water. The wonderful form of the talon finds its origins in the ancient and enormous Tyrannosaurus rex. These versatile forms can be suited for everything from the limbs of massive mechanical creations to a delicately thin-clawed humanoid. Practice the positioning of claws and knuckles, the textures of plated skin and the wicked claw forms in this demonstration, and you'll be well on your way to having one of the most useful fantasy art skills ever.

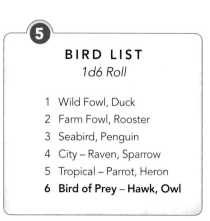

5

BIRD LIST
1d6 Roll

1 Wild Fowl, Duck
2 Farm Fowl, Rooster
3 Seabird, Penguin
4 City – Raven, Sparrow
5 Tropical – Parrot, Heron
6 **Bird of Prey – Hawk, Owl**

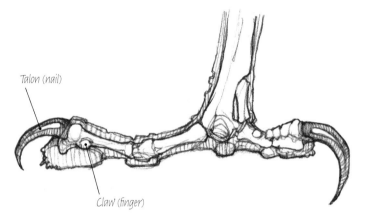

Talon (nail)

Claw (finger)

Bird Feet

There are differences among species, but the feet of all birds of prey are similar. The pads of their claws have tiny barbs called *spicules*, which give the bird a better grip. The center claw will always be the longest and the hind claw the smallest. The hind claw will also have the largest talon.

SKETCHING THE GUIDELINES
Lightly sketch the central form, the three main centerlines and the leg shafts that spread out from it. At the end of each leg shaft, draw a circle-shaped heel, and break that heel into four finger guidelines for each foot. Sketch the circle point and shapes for the knuckles of each claw pad and the guidelines that connect each claw to the heel. The center finger is always longer and curves outward unless the whole foot is clutching something.

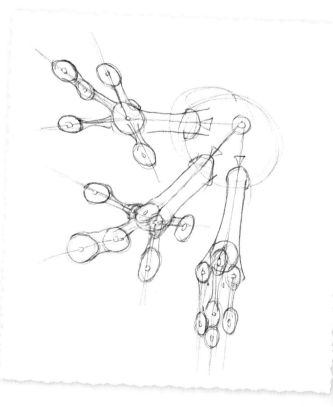

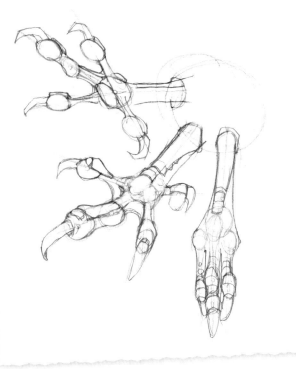

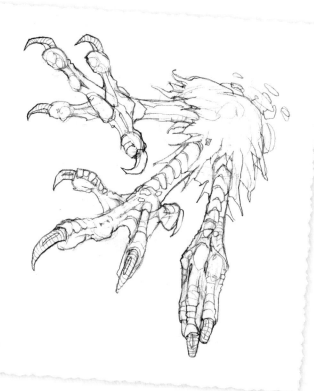

2 BUILDING THE MAJOR SHAPES

Erase the points for the knuckles and centerlines, and draw in the talons for each claw pad. Place each talon at the top of the claw pad so that it points inward to the heel. Add the skin that webs between each claw, then sketch the shapes for each foot's protective plating. Draw the plating guidelines along the tops of each knuckle right up to the cuticle of the talon and along the top of each leg shaft.

3 ADDING DETAIL

Once the major shapes are formed, erase the guidelines. Add more detail to the outlines of each foot, and refine the shape and direction of the talons. Give each talon a highlight. Break each of the plating guidelines into the scales on the knuckles and legs, and trail them off into smaller scales as they get closer to the heel. Then add feathers around the tops of the legs, and begin to map out the shadow areas underneath the forms. Draw wrinkles and bumps into the skin. Look back at the bone structure to see how the skin wraps around the bones and pads of each claw. Pay special attention to the cuticles that connect the talon to the claw.

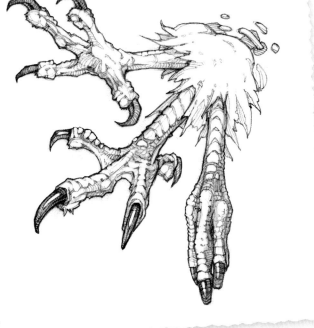

4 FINISHING

Add all the shadow areas, rubbing tone into them and sketching in hatch lines in tiny U-shapes, like the scales of fish. Darken in the talons, erasing the highlights for contrast. Refine the outlines, adding more detail to the skin and plating. Then your raptor is ready to tear into its prey!

1

PLANT LIST
2d6 Roll

2 Seaweed
3 Fern
4 Desert Cacti
5 Thick Leaf – Jade
6 Flower – Domestic
7 Vine
8 Poppy
9 Grass, Dandelion
10 Bamboo
11 Flower – Wild
12 Carnivorous

VEGGIE SET :: 1D4

2

FRUIT & VEGETABLE LIST
2d6 Roll

2 Asparagus
3 Pinecone
4 Berry, Grapes
5 Ginger
6 Tree Fruit (Apple, Orange)
7 Bean
8 Pumpkin, Gourd
9 Broccoli, Artichoke
10 Corn
11 Grain, Wheat
12 Pineapple

3

FUNGI LIST
1d4 Roll

1 Moss
2 Ooze, Jelly
3 Lichen
4 Mushroom

4

TREE LIST
1d6 Roll

1 Willow
2 Birch
3 Maple, Oak
4 Banyan
5 Pine
6 Palm

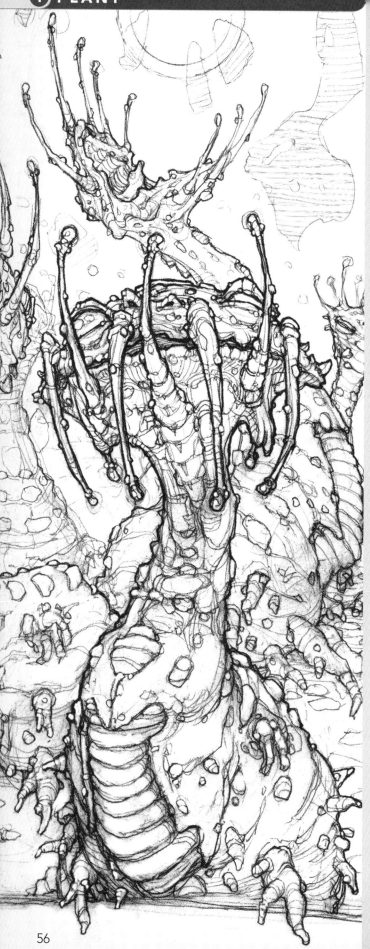

1 Plant :: 2d6 Roll

It is the Earth's plant life that sustains it. Huge tracts of rainforest balance our atmosphere miles from the surface, and as the start of the food chain, every herbivore and omnivore is almost completely reliant on the chemicals and food supplied to us by plants. Every culture has celebrated crop in harvest festivals, embroidered leaf and vine patterns onto clothing, built their homes and made their medicines from plants. Plant life can be as familiar to us as a sunlit house fern or as unfamiliar as a fungi that can live in complete darkness. They are the enormous, ancient sequoia and the tiniest lichen, the fresh-cut lawn and the weeds that spot through the cracks in the cement.

Pay special attention to growth and decay with any Plant roll, the season your plant part might be growing in, and how insects and temperature might affect its decay. Mixing two or three types of plants can give you a whole new approach to an object, humanoid or creature. When coming up with ideas for *Wreaking Havoc: How to Create Fantasy Warriors and Weapons*, I created these Venusians, relying heavily on the idea of a carnivorous plant, the Venus flytrap.

1 PLANT LIST
2d6 Roll

2 Seaweed
3 Fern
4 Desert Cacti
5 Thick Leaf – Jade
6 Flower – Domestic
7 Vine
8 Poppy
9 Grass, Dandelion
10 Bamboo
11 Flower – Wild
12 Carnivorous

FLYTRAPS AND VINES

The carnivorous plant is one of the most fascinating things alive. The gaping mouth of a pitcher plant or Venus flytrap is not only alien looking, but also anthropomorphic. Vines are equally fascinating in their rapid climbing growth, flexibility and strength. Either plant can be used for both pattern and form in any roll. The crisscrossing of vines could be used for elaborate Celtic knotwork pattern, or their tentacle-like forms could show up as the limbs of one of your creations. Here you will learn how to draw a couple different forms of vine growth, while seeing how a Plant roll might add to your creations.

①

PLANT LIST
2d6 Roll

 2 Seaweed
 3 Fern
 4 Desert Cacti
 5 Thick Leaf – Jade
 6 Flower – Domestic
 7 Vine
 8 Poppy
 9 Grass, Dandelion
10 Bamboo
11 Flower – Wild
12 Carnivorous

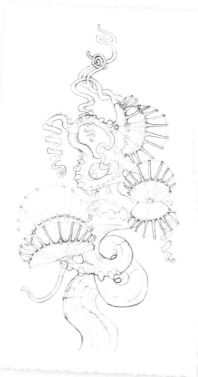

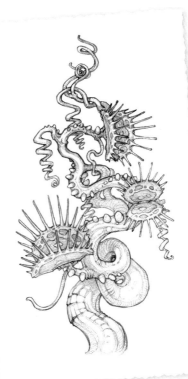

SKETCHING THE GUIDELINES
To plan a vine structure, keep even gaps and spaces so the eye easily moves from trunk to tip. Start with an expressive centerline for the vine to follow, then use your whole arm to loop and curl the vine around the centerline, going from a thick trunk at the bottom to increasingly thinner and curvier vines at the top. Draw through and don't worry about what vine will appear in front or behind, as it will change by the time you've filled in everything. Draw a series of evenly spaced ovals getting smaller at the bottom for drooping vines. Place clam shapes that will become flytrap mouths at the ends of empty vines, and extend a guideline that follows that shape. Map out the points along each clam shape's outer edge, and place a major point directly behind the hinge of each mouth.

2 BEGINNING DETAILS
Draw the teeth by connecting the major point to all the points along its outer edge. The tip of each tooth ends along the outer guideline. Connect the drooping vine ovals with crisscrossing lines, so they look like curls of hair. Outline all the vines, warts and parts of the mouths, adding wrinkles and marking out shadows running along the direction of each vine. The warts spiral around the centerline of the bigger vines and trail off in size before reaching to the newest shoots of growth.

3 FINISHING
Add more details to the trunk and thicker vines with splits and wrinkles around the major curls and warts. Draw the pattern into the mouths of each of the flytraps, and shade in the dark areas. Darken all the outlines. Erase any remaining guidelines, then add shadow areas along each vine with directional hatch lines.

FERNS, GRASS AND FLOWERS

Flowers can be both beautiful and deadly. They inspire both romance and mystery. Their symmetrical petal forms could be used for costuming or mechanical design, and their endless supply of patterns always looks good wrapping across the skin of creatures and objects. In this demonstration we'll play with an alien hybrid orchid that will mix several different possible rolls: Flower – Domestic, Fern and Grass. When sketching, notice how anthropomorphic and mobile a flower can look, how the coils of unraveling fern growth can resemble fists and how the growth of grass can be used as hair in any of your creations. Never be afraid of exploration! After this demonstration, try to replace the different parts of this hybrid with the parts of other flowers and plants that you like. Watch how plants grow in the springtime and decay in the autumn.

1

PLANT LIST
2d6 Roll

2	Seaweed
3	**Fern**
4	Desert Cacti
5	Thick Leaf – Jade
6	**Flower – Domestic**
7	Vine
8	Poppy
9	**Grass, Dandelion**
10	Bamboo
11	**Flower – Wild**
12	Carnivorous

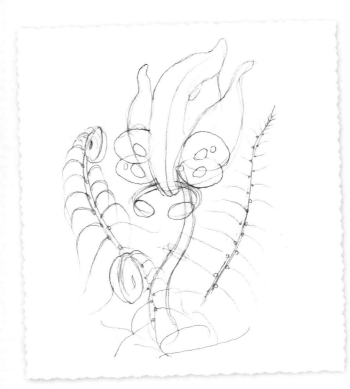

Drawing an Ellipse

1. Begin with cross guidelines.
2. Mark out equal measurements both horizontally and vertically.
3. Draw a curved line from each point to form the ellipse, making sure to keep each segment as evenly formed as possible. Short, thin ellipses convey a tube or disk form from side angles, whereas a full circle shows them from top or bottom.

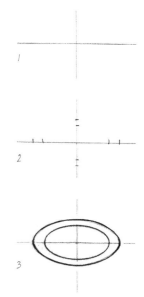

SKETCHING THE BASIC SHAPES

Lightly sketch guidelines for the main stem and the petal shapes that will become the head and eyes. Start the grass growth with three wavy shapes, and place a centerline down the middle shape. Then draw an ellipse and two pod shapes at the ends to form its pincer pods. For the fern leaves, draw in the main stem guidelines and staggering circle points from side to side along the whole length of each of them. Then extend out branching stem guidelines from those points making them smaller as you get to the tops. End two of them with donut shapes that will become the fern fists.

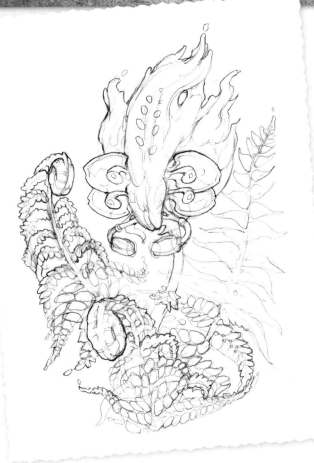

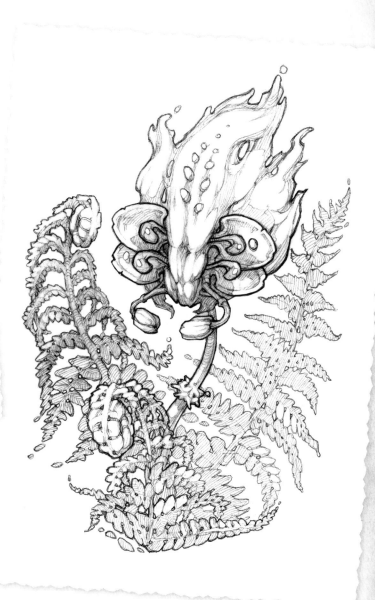

2 BEGINNING DETAILS

Roughly sketch out the triangular shapes of each branch extending from the fern stems, then fill them in with tiny leaves. Just like the branches, stagger each tiny leaf shape running up the length of the branch, making them smaller as they go toward the tip. Outline the fist shapes and the shapes of negative space between each branch, silhouetting the bottom-lying branches. Sketch more of the details of the head by breaking the grass shapes into more waves, adding warts that run along the centerline and placing shadow guidelines to define the forms. Then detail and outline the parts of the hybrid's face: the four orchid petals, the pistil eyes in front of them and the pincer pods.

3 FINISHING

Detail and darken the outlines, filling in all the shadow areas underneath the lumps and forms of the hybrid. Erase back any highlights that have gotten muddy. Concentrate on the fists and face of your flower as your focal points, making the outlines and shadows darker. Notice how the orchid petals become translucent by adding in a shadow that follows the lines of the shapes behind them.

BELIEVABLE FERN LEAVES

The secret to making believable fern leaf growth is in the fractal repetition that first branches along the main stem, then again with leaves branching off each smaller staggered stem. Notice how the new growth shapes unravel from the fists; the branches droop down at the top and lift up to the light at the bottom.

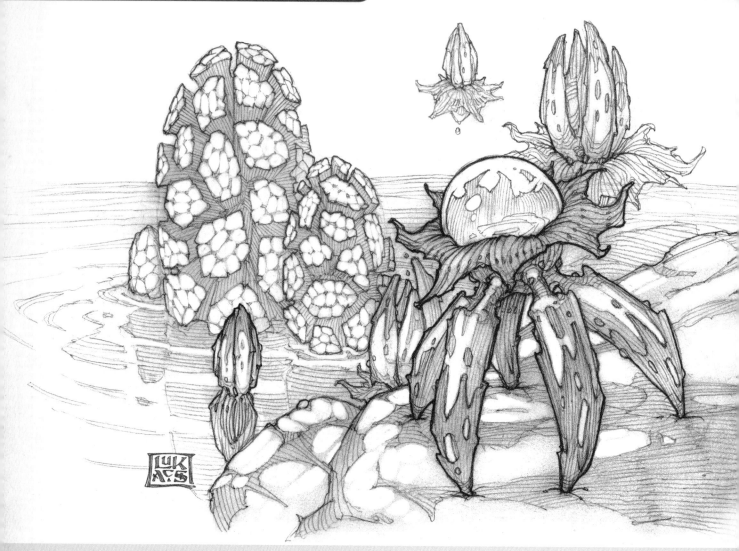

2 Fruit & Vegetable :: 2d6

Fruit & Vegetable can be used for both form and pattern. When you roll Fruit & Vegetable, keep in mind all the different parts of each item. A pineapple can encompass everything from the hexagonal pattern of its skin or its cross-section to the cluster of leaves on the top. Grain might incorporate a whole field of wheat used as hair, as a Pinecone roll could be used for the pattern that the needles make as they intersect with each other.

②

FRUIT & VEGETABLE LIST
2d6 Roll

2 Asparagus
3 Pinecone
4 Berry, Grapes
5 Ginger
6 Tree Fruit (Apple, Orange)
7 Bean
8 Pumpkin, Gourd
9 Broccoli, Artichoke
10 Corn
11 Grain, Wheat
12 Pineapple

PINECONE

The spiraling technique for drawing the pinecone and berry (see page 62) is the basis for the way many animals and plants grow in both macro and micro forms. The key to adding Fruit & Vegetable pattern and form to your creations is repetition.

②

FRUIT & VEGETABLE LIST
2d6 Roll

 2 Asparagus
 3 Pinecone
 4 Berry, Grapes
 5 Ginger
 6 Tree Fruit (Apple, Orange)
 7 Bean
 8 Pumpkin, Gourd
 9 Broccoli, Artichoke
10 Corn
11 Grain, Wheat
12 Pineapple

SKETCHING
Lightly sketch the basic shape of the pinecone. Space out and draw seven or eight S-shaped crisscrossing guidelines as shown. Notice how the guidelines map out the intersecting segments of the cone and form the gaps between each one.

2 OUTLINING AND FINISHING
Outline the negative shapes formed by the guidelines with a smaller diamond shape inside each segment, keeping in mind the segments will point outward as you get to the edge of the cone. Darken the guidelines, and finish the pinecone with the wrinkles and details in each segment. Remember, repetition is the key to a good cone.

BERRIES

Use the spiraling technique for creating the look of berries, also.

SKETCHING THE GUIDELINES
Sketch in a long and curved stem, and just like in the spiraling pinecone, space out seven or eight S-shaped guidelines running up the stem. Then place circle markers along the guidelines for each berry that will be facing forward.

2 BEGINNING DETAILS
Sketch each forward-facing berry shape along the circle markers, making them smaller as you get to the top of the stem. Then add the stems that connect each berry to the main stem. The berries curve and spiral around the stem just like the segments of the pinecone.

3 FINISHING
Darken the backward-facing berries and add the wrinkle details and shadows to each berry.

BUMPY AND SPIKY GOURD

Melons and gourds are very diverse in both structure and pattern. There are, however, a couple general similarities you can count on. They all grow from vines, and both pattern and structure flow from where the fruit connects to the vine. So no matter how curvy your gourd might get, its patterns, spikes and bumpy skin will always flow from one central point.

②

FRUIT & VEGETABLE LIST
2d6 Roll

2 Asparagus
3 Pinecone
4 Berry, Grapes
5 Ginger
6 Tree Fruit (Apple, Orange)
7 Bean
8 Pumpkin, Gourd
9 Broccoli, Artichoke
10 Corn
11 Grain, Wheat
12 Pineapple

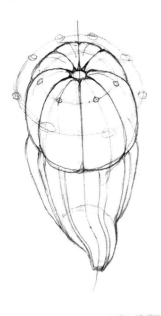

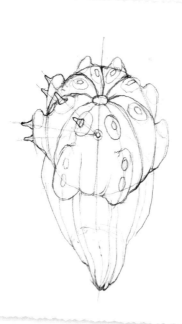

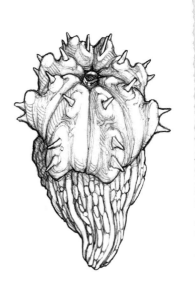

1 SKETCHING THE GUIDE-LINES

Lightly sketch in a centerline, giving it a curl at the bottom. Add both the major upper and lower shapes, breaking the upper sphere into eight sections, making it look something like an orange on top. Run centerlines up each section, and draw in the ellipse guidelines and circle markers to map out where the tip of each ridge will be placed. Then break the lower shape into thick and thin sections that follow the curled centerline.

2 BEGINNING DETAIL

On each segment of the upper orange shape, draw in the wart ridges running up the gourd. Place more circle markers on each wart from which a spike will grow. Place a point somewhere along your centerline, and from that point draw guidelines out to the many circle markers. This will show you the direction the spikes will shoot from. Then draw in those spikes.

3 FINISHING

Along the lower curled shape, fill in the thick sections with a random series of bumps, making them shorter at the top end and longer as they swirl around with the form to the bottom. With all the major and minor forms in place, finish off the gourd by darkening all the outlines, filling in the shadow areas and erasing any highlights.

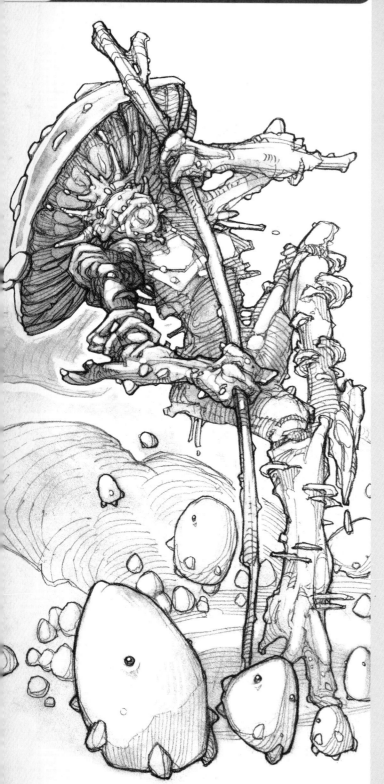

3 Fungi :: 1d4

Mushrooms and other fungi grow from decay. The ancient Egyptians used the life cycle of the dung beetle as a symbol for rebirth from death, and fungal growth can be seen in a similar way. There are a countless variety of caps and gills that form in total darkness, and the mutated and odd forms that grow from the rot of wood hidden deep in the forest. Some are tasty and nourishing; others are as toxic and deadly as poison. There's a wide range of photo reference available on fungi, as most forms are so alien to us that we are fascinated and wonder at what they are. A Fungi roll opens any fantasy geneticist up to a huge potential for pattern and an endless variety of form for any of your creations.

3

FUNGI LIST
1d4 Roll

1 Moss
2 Ooze, Jelly
3 Lichen
4 Mushroom

MUSHROOMS AND LICHEN

In this demonstration we will cover three different kinds of fungi: the basic gilled mushroom, the scale-like turkey tail fungus and hairy lichen growth.

FUNGI LIST
1d4 Roll

1 Moss
2 Ooze, Jelly
3 Lichen
4 Mushroom

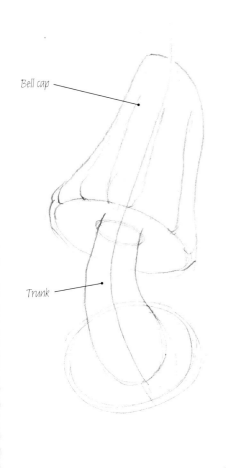

Bell cap

Trunk

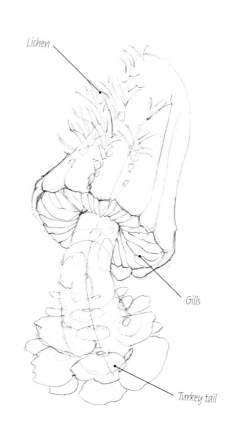

Lichen

Gills

Turkey tail

SKETCHING
Draw the curved centerline of the mushroom. Then lightly sketch the trunk, bell cap and the ellipse guidelines for where the turkey tail fungus will go. Draw ridgelines up the main bell cap following the curve of your centerline.

2 BEGINNING DETAIL
Lightly draw ellipse guidelines along the trunk for both the rips on the trunk skin and turkey tail shapes below. Sketch the gills using U-shapes drooping down from the inner and outer guidelines. These gills don't have to be perfect—some go only halfway between the guidelines—but they should look evenly spaced and uniform. Use the ridgelines to lightly sketch in the groups of lichen, fading them at both the top and bottom of the bell cap.

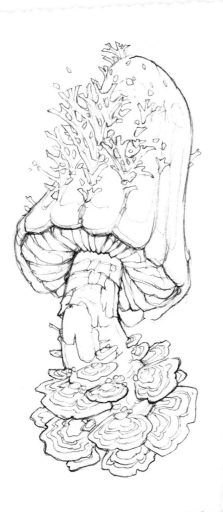

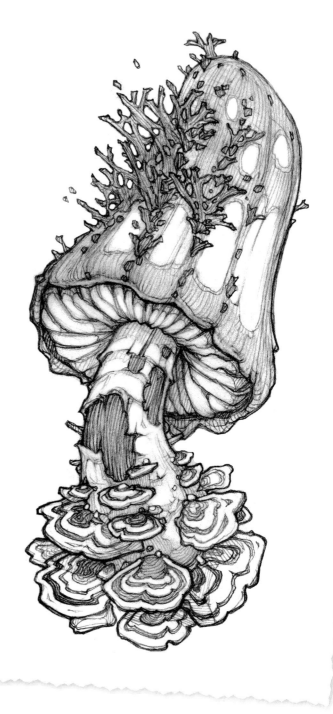

3 ADDING OUTLINES AND DETAIL

Start to outline and detail the strands of lichen. Notice how the tips of each strand will end at the same length and crisscross and form like the pine foliage on page 69. Start to sketch in the shadow shapes of the mushroom gills and the wrinkles and tears in the skin of its trunk. Erase the ellipse guidelines. Sketch the grouping of turkey tail fungi by first outlining each one with a wavy line. The shapes higher up on the trunk will overlap the ones below them. Then draw their concentric pattern by following the wavy outline, repeating that same outline smaller and smaller as you get closer to the trunk.

4 FINISHING

Erase any remaining guidelines, then add more details to all the outlines to define each fungus. Add in tiny warts to the base of a couple of the turkey tails to show fresh growth. Rub your finger along the lines of the gills to soften them, and shade in the remainder of the shadow areas using directional hatching specifically for the lichen shapes, the openings in the trunk skin, and the concentric pattern of the turkey tail fungi.

4 Tree :: 1d6

The sight of light streaming through autumn leaves is a beauty to behold. Whether it's pine needles and cones reaching to the sun to collect light, or randomly scattered maple leaves across the forest floor or veins that spread like arcs of electric charge from a Tesla coil, tree leaves form an endless variety of form and pattern. Clusters of foliage can become anything from furry hair to weapon blades. Individual leaf shapes and the fractal-like and electric patterns in individual leaves can be repeated across any form as scales or armor, or can be used to wrap around any object.

Each species has a different personality to be learned, and a good fantasy geneticist will study every one and find photographic reference for as many examples as possible. If you keep a couple tricks in mind, mixing trees into your creations will quickly become second nature to you.

4

TREE LIST
1d6 Roll

1 Willow
2 Birch
3 Maple, Oak
4 Banyan
5 Pine
6 Palm

FOLIAGE FUNDAMENTALS: LEAVES

In this demonstration you'll learn the foliage fundamentals of the two major families of trees: deciduous and coniferous. Deciduous tree branches, like the maple branches below left, have thousands of flat leaves, making their foliage flatter and wider. Coniferous tree branches, like the pine branches below right, have needle-like leaves, making their foliage thicker and spikier.

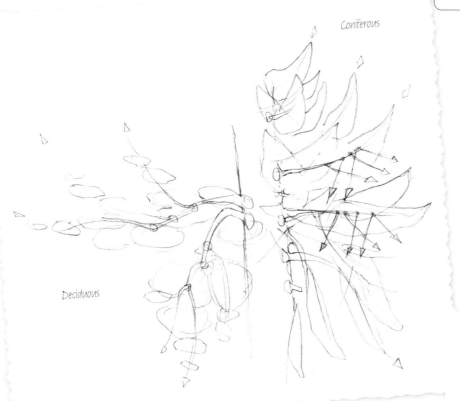

Coniferous

Deciduous

FOLIAGE = HAIR

Think about foliage the same way you would someone's hair. Don't worry about each hair or each individual leaf. It's more about the shape and design of the whole clump of leaves or the whole head of hair.

SKETCHING THE TRUNK AND MAJOR BRANCHES

Sketch the trunk and major branches—maple on the left, pine on the right. I chose to make this trunk straight, but you can make yours as gnarled and flowing as you like. Don't worry about sketching detail into anything, as we're just looking to give direction to where the foliage will spread across the branches.

Pine branches are a bit more evenly spaced at the trunk, crisscrossing as they get closer to the tips. Both types of branches lift higher at the top, while the older lower branches dip towards the ground. Draw in the major shapes that will become big clumps of leaves. The maple shapes should be more rounded, getting smaller as they reach the tips of each branch.

Coniferous

Deciduous

2 BEGINNING DETAIL

Once you've sketched in the direction of the branches and the foliage shapes, start outlining the foliage edges. Erase the major branch and shape guidelines, and add more detail to the edges of those shapes. As you sketch, think of the pine foliage as clumps of bananas and the maple foliage as flat pointy pieces of paper stacked together. In the tighter spaces, start to outline the negative spaces between the branches and leaves where light will pass through. After making the foliage outlines, lightly sketch in the shapes of light and shadow on each cluster of leaves; add more light at the tips of the branches and more shadows as the clusters get closer to the trunk. Then start to draw individual leaves and cones (on the right only). Erase the branch lines as you stagger smaller leaves out to the tip, and throw in a leaf or two falling to the ground.

Coniferous

Deciduous

3 FINISHING

Fill in the lightly sketched shadow areas following the direction of the foliage and original branch direction to give your tree more movement. Darken the outlines that form each pointy leaf detail and branch bark that peeks out from behind the clumps of foliage (see page 70). Rub your finger lightly over the shadow areas and erase back into any highlights on the clumps of foliage, or negative areas between branches and leaves, that need to be brought back out.

FOUNDATIONS: ROOTS, TRUNKS AND BARK

Here we'll cover the foundation of a tree: roots, trunk and bark. For this demonstration I've chosen an old, cantankerous, one-armed treant friend to show all three techniques in one. In most creatures the trunk will normally act as a form, but both roots and bark can cover any form as a skin pattern. This demonstration will also serve in showing the way an Action roll can be used (see page 112). I rolled Throw for this treant.

4

TREE LIST
1d6 Roll

1 Willow
2 Birch
3 Maple, Oak
4 Banyan
5 Pine
6 Palm

KNOTS AND BURLS

Knots form on trees where a branch has been broken or cut off. They will also form where insects have nested, destroying some of the outer layers of bark. Think of them as the scar tissue that forms around a healed wound. Knots and burls on a trunk or branch appear smoother and often have a ring around them where the dead branch has fallen off. Sometimes they even look like ears or eyes on a tree.

SKETCHING

Roughly sketch the gesture. Hold your pencil between your thumb and forefinger to get a better flowing motion of your whole arm. Draw the main arch of the trunk and directional guidelines where the bark will be. Place the arm holding the rock to be thrown, the knot-socket where his missing arm appears, the rough features of his face, and guidelines for his knuckles and fingers. Sketch circle markers, and fingers between them, like you did in the paws demonstration (see page 40).

Roots :: Banyan roots and branches can look like roots above ground. Begin sketching the rootlike pattern across the lower trunk, noticing how they crisscross and form a pattern similar to Celtic knotwork around the lower trunk. Don't worry about detail. Draw through each branch as fluidly as you can.

2 ADDING DETAIL

Start detailing the outlines of each flowing branch and the foliage that springs from it. Each branch gets smaller and straighter as it gets farther from and higher up the trunk. Add more detail on the face, including the brow line, eyes, lids, jowls and knots that will become the ears.

Bark :: Use the guidelines along the upper trunk to start sketching each piece of bark. Follow the original flow of your guidelines as they curve around the trunk. Each piece of bark should be random, not all the same size. For bark pattern, go in one direction and draw in each piece of bark, making the pieces thinner as you get to the sides of the trunk.

Roots :: Add more details into each root that streams around the lower trunk. These roots are like a system of veins wrapping around the trunk—the legs and feet of the tree. Erase back and forth to get a nice pattern of veins that weave into each other. Lock them in by outlining the negative spaces between each weave. The veins of roots get smaller as they trail off at the ends of his feet and knuckles.

3 FINISHING

Add details to the outlines of the trunk, noticing how the pieces of bark curl where the trunk is bending. Follow the direction of your original guidelines, and shade in the shadow hatching on the arm, and background foliage and along the underside of each flowing branch.

Bark :: Add a tiny line of shadow underneath each piece of bark. Erase and thin the lines on the tops of each piece. You can get a fuller piece of bark by drawing in shapes inside each piece as well; this will give them the look of a topographic map.

Roots :: Darken the outlines of the roots, defining the curves of the veins that wrap around the trunk, then down to the fingers, and taper at the knuckles. Add shading in the gaps between the roots, again following your original trunk and limb guidelines.

① FIRE & ELECTRIC LIST
1d4 Roll

1 Fire, Vapor
2 Electric Bolt
3 Ember, Hot Coal
4 Molten Lava

ELEMENTAL & MINERAL SET :: 1D4

② LIQUID LIST
1d8 Roll

1 Icicles
2 Fog, Vapor
3 Wave
4 Dew Drops
5 Ripple
6 Frost, Snow
7 Suds, Bubbles
8 Tar, Gum

③ EARTH & METAL LIST
2d6 Roll

2 Malachite
3 Mountain, Cliff Face
4 Brick, Cobblestone
5 Rust, Oxide
6 Cracked Clay
7 Stalactite, Stalagmite
8 Glass, Crystals
9 Powder, Sand
10 Slate, Shale
11 Cement, Sediment
12 Mercury, Chrome

④ ASTRAL & ATMOSPHERIC LIST
1d8 Roll

1 Moon Cycles
2 Starfield
3 Crater, Asteroid
4 Solar Flare
5 Galaxy Form
6 Volcano
7 Planets, Saturn's Rings
8 Cloud, Cyclone

1 Fire & Electric :: 1d4

In the Fire & Electric roll we'll find an explosion of light, form and pattern. Fire and electricity grow out and multiply from their source a lot like branches sprout from the trunk of a tree. It's always good to look at slow-motion video and fractal images whenever you're trying to capture fire, electricity or anything chaotic. A Fire & Electric roll is an opportunity to make your creation dynamic and filled with action! Your creation could have fire or electricity as hair and shoot either of them as a weapon from its mouth or hands. Or their pattern could be used to accent your creations, like the door panel of a hot rod car.

1

FIRE & ELECTRIC LIST
1d4 Roll

1 Fire, Vapor
2 Electric Bolt
3 Ember, Hot Coal
4 Molten Lava

ELECTRIC BOLTS

Much like the veins on a maple leaf or the roots of plants, electricity spreads and multiplies from a starting point. Keep in mind the size and the direction in which the electric is spreading. Double and triple the number of bolts as the electric spreads from its source.

Search online for reference photos using key words, such as: *tesla coils*, *science museums* and *nature photography*.

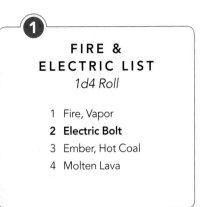

> ### 1
> ### FIRE & ELECTRIC LIST
> *1d4 Roll*
>
> 1 Fire, Vapor
> **2 Electric Bolt**
> 3 Ember, Hot Coal
> 4 Molten Lava

SKETCHING

Start with lightly drawn and expressive guidelines. Hold your pencil with your index finger and thumb, and draw your guidelines out from the source. If you watch electric bolts in slow motion, you'll notice each branch gets thinner as it multiplies and will start to ripple into S-shapes at the source.

2 BUILDING THE BRANCHES

Thicken and ripple each branch of electric current at the source, and further define the many branches. Erase where each bolt crosses with another, and darken the outlines around those connective joints.

3 FINISHING

Add detail to your electric explosion with a couple more thin bolts closer to the source and some directional hatch lines to show the rippling movement.

RINGS OF FIRE

Like electricity, fire flows and spreads from one source and spins and curls upward from that source. Each artist captures fire in a different way. The best way to understand it is through observation and photo reference. Watch the trails of smoke from incense or the tongues of flame from a campfire.



① FIRE & ELECTRIC LIST
1d4 Roll

1 **Fire, Vapor**
2 Electric Bolt
3 **Ember, Hot Coal**
4 Molten Lava



1 SKETCHING

Start with a circle of coal chunks as the fire's source. Draw them lightly and randomly, but make sure they will form a dark circle for the source of your fire to contrast with. Like the electric bolts, start with dynamic and expressive guidelines for flames. Don't be afraid to erase parts as you go. Explore spiraling shapes and the combos of straight and curved lines. In many ways, fire can be fluid like water or smoke.

2 BEGINNING DETAILS

Darken in the chunks of coal, making angular shadow areas on each. Notice how the chunks are lighter where the fire cuts in front. Start to outline the major shapes of flame. Flame shapes will be more rounded and bulbous near the source and then shoot out as thin, wispy shapes at the top of the fire.

3 FINISHING

Rub in tone and erase out highlights. Fire is its own light source, so it will always get lighter as it gets closer to its source and darker as it floats and burns away. Add more movement to your flames with hatch lines that follow the upward direction of the fire.

2 Liquid :: 1d8

Again we visit the underworld as we did in the Sea Life List (page 16). Here we will find all the same mixing and associations of underwater habitats, but a Liquid roll will bring your creations anything from the patterns of ripples or snowflakes to icicle horns, sticky tar weapons or water vapor issuing from bursting bubbles. Liquid could also bring your creations transparency, the sense of chill winter or of warm sandy beaches in summer. A liquid landscape includes ice, snow and waves, along with opaque water and the vapor of clouds.

②

LIQUID LIST
1d8 Roll

1 Icicles
2 Fog, Vapor
3 Wave
4 Dew Drops
5 Ripple
6 Frost, Snow
7 Suds, Bubbles
8 Tar, Gum

DROPS, POOLS AND BUBBLES

In this demonstration, you'll learn the basics of bubbles, drops and ripples. When sketching transparent liquid, look at pictures of glassware, clear lamp-worked glass and glass sculpture. Transparent liquids have bright highlights against dark shading where the light enters and bends inside the form, and sometimes they have a clean rim light surrounding the outline of the form.



②

LIQUID LIST
1d8 Roll

1 Icicles
2 Fog, Vapor
3 Wave
4 Dew Drops
5 Ripple
6 Frost, Snow
7 Suds, Bubbles
8 Tar, Gum



1 SKETCHING
Lightly sketch two centerlines and the concentric ellipses that will form your ripples. Think of the very center as the point of impact of the drop of water. Then sketch the base guidelines for each bubble cluster. Make the bubble bases random in size and a little wider than the ripple guidelines. Notice how the ellipse guidelines are thinner at the top of the sketch and get longer as they reach the bottom.

2 BEGINNING DETAILS
For every bubble base, add a bubble outline on top of it and some random foam surrounding the bigger clusters. Draw the rounded forms that make the splash crown. Notice how each drip shoots out from the center point of impact.

3 SHADING
Shade all the liquid forms, keeping in mind that you are looking inside them. Follow the original guidelines to create the shadows inside the liquid. Each highlight should remain bright against the dark shading. Notice when shading in the ripples that the splash reflects in the water below, as any reflective surface will.

4 Astral & Atmospheric :: 1d8

The Astral & Atmospheric List brings us the forms and patterns of craterous asteroids, planet surfaces, galaxies and star constellations. You may use the rings of Saturn to encircle humanoid ears or ankles, make tentacles or tails spiral like a cyclone or cover a flea form with the craters of the moon.

When searching for astral reference, look to images of the Hubble Space Telescope and the Mars rovers from NASA's website (www.nasa.gov). Search the vast catalog of public satellite and telescope imagery of planets, star clusters, spinning cyclones and volcano clouds.

4

ASTRAL & ATMOSPHERIC LIST
1d8 Roll

1 Moon Cycles
2 Starfield
3 Crater, Asteroid
4 Solar Flare
5 Galaxy Form
6 Volcano
7 Planets, Saturn's Rings
8 Cloud, Cyclone

RINGS, ASTEROIDS, SOLAR FLARES

In this demonstration, you'll learn to draw Saturn's rings, the spiraling tails and craters on an asteroid sphere, and exploding solar flares.

> ❹
> ### ASTRAL & ATMOSPHERIC LIST
> *1d8 Roll*
>
> 1 Moon Cycles
> 2 Starfield
> **3 Crater, Asteroid**
> **4 Solar Flare**
> 5 Galaxy Form
> 6 Volcano
> **7 Planets, Saturn's Rings**
> 8 Cloud, Cyclone

SKETCHING

Draw a centerline for all the forms to run along. Cross that centerline with another line, measure out equal distances on either side of it, and draw the ellipse guidelines to form the biggest ring. Then draw guidelines for the asteroid and the rest of the smaller rings. I used a compass for the circles and an ellipse template for the smaller rings. Notice how the rings seem much thicker at their ends when drawn in perspective.

2 BEGINNING DETAIL

Lightly sketch out the crater shapes and shadow areas that form inside each one. They should be jagged and get thinner closer to the edge of the asteroid. Each crater also has a lip around its edges, which will show up in the shadows. Draw two more guidelines on each side of the centerline emanating from the center of the asteroid. Then lightly sketch the free-form expressive lines of the solar flares much like the fire demo on page 76.

3 FINISHING

Finish your astral cluster by darkening the shadow areas around and inside each crater. The light source is coming from the top left, so the inside and lip of each crater catches the light. Darken the outlines around each astral form, and erase any guidelines.

SHADING CRATERS

Take a shallow rice bowl and slowly turn it around in a light at your left. Look at the shape of the lip of the bowl and how the shadow falls on the inside of the bowl, then sketch your craters the same way.

CRYSTAL AND CLAY

An Earth & Metal roll gives the fantasy geneticist the ability to turn any creation to stone and more. You may want to make the crest of a lizard creature out of crystals, the head of a humanoid topped with a mountain cliff or the side of a giant metal squid filled with rusty holes. When looking up reference for creations of earth and metal, look for the patterns of polished stone, geological surveys and mountain landscapes. Also explore science museums, rivers and waterfalls for rocks and interesting stones.



③ EARTH & METAL LIST
2d6 Roll

- 2 Malachite
- 3 Mountain, Cliff Face
- 4 Brick, Cobblestone
- 5 Rust, Oxide
- **6 Cracked Clay**
- 7 Stalactite, Stalagmite
- **8 Glass, Crystals**
- 9 Powder, Sand
- 10 Slate, Shale
- 11 Cement, Sediment
- 12 Mercury, Chrome



SKETCHING

Sketch in a guideline for the patch of cracked clay and a circle in the center from which the crystal growth will spring. Break the main shape into two or three more cluster shapes where the largest crystal stems will form and the smaller crystals will bunch around. Then lightly sketch in the direction of each twisted crystal as it stems from its cluster shape.

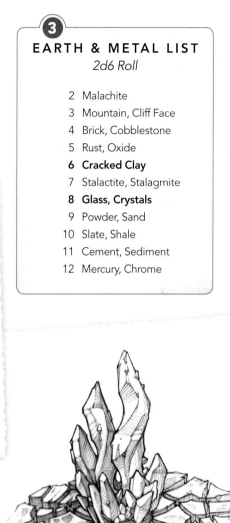

2 BEGINNING DETAILS

Sketch the twisted and angular outlines of the main crystals, then make smaller pointed crystal shapes at the base of each of them. Begin the cracked clay with intersecting and random guidelines, making them thinner as they trail behind the crystal. Erase the intersecting lines to form the cracks in the clay.

Outline each piece of cracked clay with the edges flared upwards, and give each piece depth by drawing lines down from each of its points, like the one shown.

3 FINISHING

Add shadows and reflections along all the jutting stems. Add smaller cracks and details to the pieces of cracked clay and darken all the cracks in between to bring out the contrast.

TRANSPORTATION LIST
1d8 Roll

1 Car, Truck, Bus
2 Aircraft
3 Rail, Train, Trolley
4 Cycle
5 Sled, Ski
6 Boat, Ship
7 Spacecraft
8 Tank Tread

ARCHITECTURE LIST
1d8 Roll

1 Ornament, Gargoyle
2 Bridge, Framework
3 Castle, Domed
4 Ornament, Pillar
5 Modern Skyscraper
6 Place of Worship, Totem
7 Doorway, Archway
8 Old Village, Cottage

TOOL LIST
2d6 Roll

2 Drill
3 Cups, Plates
4 Umbrella
5 Bundle, Bale
6 Hammer, Axe
7 Brush – Hair, Tooth
8 Razor, Knife
9 Spigot, Faucet
10 Rope
11 Silverware
12 Lock, Key

TECHNE SET :: 1D6

4

MACHINE LIST
1d6 Roll

1 Switch, Dial, Button
2 Turbine
3 Bulb, Lamp
4 Clock, Gears
5 Fan, Propeller
6 Saw

5

TOOL LIST
2d6 Roll

2 Adhesive, Bandage
3 Shovel, Pick
4 Capsule, Tablet
5 Nuts, Bolts
6 Chain
7 Thread, Stitch
8 Shears, Scissors
9 Pen, Paintbrush
10 Spring, Coil
11 Syringe
12 Tube, Plumbing

6

MACHINE LIST
1d8 Roll

1 Reactor Core
2 Telephone
3 Solar Panel
4 Engine
5 Laser Beam
6 Microchip
7 Dish Antenna
8 Rocket

1 Transportation :: 1d8

This is our chance to explore the vast number of ways humans get around. Will your Transportation roll bring your creation land vehicle elements, like muscle cars of the `70s or the staged rockets of the space shuttle? Do you want the look of a jumbo jet, a Wright brothers' glider or a hot air balloon?

Like in any Techne roll, think about design periods and art movements, science fiction movies and historical war vehicles. My Transportation reference includes antique and futuristic design elements: propeller planes and rocket engines, old rusted tractors and sleek, Art Deco trains. One of my favorite ways to use Transportation is in costuming because the sleek design and shapes in old vehicles, auto fenders, and plane cockpits can become shoulder pads and armor, and the riveted and louvered pattern of steel panels can be used virtually anywhere.

① **TRANSPORTATION LIST**
1d8 Roll

1 Car, Truck, Bus
2 Aircraft
3 Rail, Train, Trolley
4 Cycle
5 Sled, Ski
6 Boat, Ship
7 Spacecraft
8 Tank Tread

WHEELS AND TREADS

Most land transport requires wheels, tracks or treads. Look at the mechanics of cars, trains and tanks. Isolating the function of just one part of any wheel assembly or subway train might make your next Transportation roll your best. Get ready to engage the engines; we're about to take a ride!

Upside-down bee head

> ### 1
> ## TRANSPORTATION LIST
> *1d8 Roll*
>
> 1 **Car, Truck, Bus**
> 2 Aircraft
> 3 Rail, Train, Trolley
> 4 Cycle
> 5 Sled, Ski
> 6 Boat, Ship
> 7 Spacecraft
> 8 **Tank Tread**

Thumbnail Sketches

Some of the best vehicle design comes from nature; I regularly look at my insect reference when playing around with vehicle design. I start with thumbnail sketches of different simple design ideas, then expand on the ones I like. I picked the treaded transport vehicle and the spacecraft with aircraft elements, but notice the thumbnail that's been taken from the upside-down head of a bee.

SKETCHING GUIDELINES AND SHAPES

Lay down the perspective guidelines and basic shapes for the main wheels, axles and leg-shaped shock absorbers that the treads will move along. Draw through and change the shapes that look out of perspective.

2 BEGINNING DETAILS

Break each tread into equally spaced segments following the original perspective and making the segments thinner as they get farther away toward the back of the vehicle. Then form the main casing and driver's cockpit. Add more details to the insides of your main wheels and shock absorber arms.

DRAW FROM PROPS

I keep a number of windup toys, especially cars and spaceships, around my drawing table when I'm drawing techs and mechs. Drawing from life with actual props and toys will always make your wheels, gears and mechanisms look more convincing.

3 FINISHING

Add the support wheels in between the main wheels, as well as headlights and a work ladder to show the massive scale of the transport. Erase the remaining perspective guidelines. Add more details and shadow areas behind all the wheels and inside the cockpit. Then erase the highlight on the shiny points of each mechanical part.

SPACECRAFT

Even though a spacecraft doesn't need the parts of an aircraft or vice versa, we often want to mix and match them for more interesting designs. We recognize a couple parts in a design, and it makes all the difference in believability. Here we'll work with the cockpit of a jet, odd levitation bubbles and engine devices, making this vehicle look worthy of air and space.

① TRANSPORTATION
LIST
1d8 Roll

1 Car, Truck, Bus
2 Aircraft
3 Rail, Train, Trolley
4 Cycle
5 Sled, Ski
6 Boat, Ship
7 Spacecraft
8 Tank Tread

SKETCHING IN PERSPECTIVE

Lay down light perspective lines and mark the direction the different parts will follow. Then draw the main shapes of the cockpit and wings, and the ellipses of the big jet engine and cannons along those guidelines. Roughly sketch through each part, and measure distances with your pencil to keep your ship symmetrical.

2 BEGINNING DETAILS

Sketch in more details to your big jet engine to show movement, ensuring that the curve of the ship's body conforms to the turbine and cone. Add the bases for the mechanical bubbles on each wing and all the shapes for the connective tubes and headlights. Also draw in the shadow guidelines underneath the major shapes to reinforce the forms.

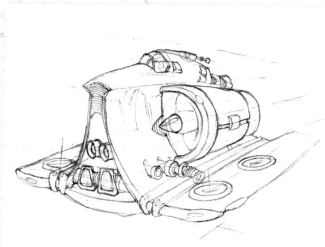

3 FINISHING

Add tone and hatching to fill in shadow areas. Then erase all remaining guidelines, and draw with your eraser to lift out the highlights on all the shiny parts of your craft. The glass on the cockpit and wing bubbles is drawn exactly like the bubbles on page 78.

HINT: SHOWING MOTION

Excluding the blades of any turbine will indicate that it's spinning.

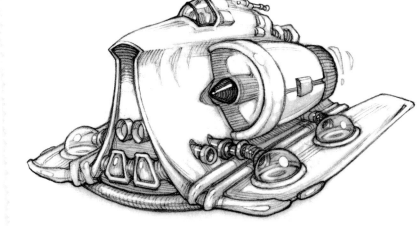

WOOD, STONE AND MORTAR

Here you can construct with bricks and mortar or mortise and tenon. You might find a swirling plaster molding or pillar design to ornament your creature's shell or chest plate, a dome or whole city on the top of your humanoid's head to play with scale, or your spider lined with girders and rivets. Keep in mind building materials and levels of decay with any Architecture roll. Will your architectural element be created with polished wood and brass fittings, old and crumbling stone or futuristic solar cells? Also think about the different periods of architecture: Art Deco, Art Nouveau or Mission Style. Search the Web for modern interior elements, historical fixtures and cool structural references.

In this demonstration you'll learn some architectural construction elements that could be used in the Castle, Dome; Doorway, Archway; and Old Village, Cottage rolls: brick and plaster pattern, arched windows and doorways, and mortise and tenon wood joints.

2

ARCHITECTURE LIST
1d8 Roll

1 Ornament, Gargoyle
2 Bridge, Framework
3 Castle, Domed
4 Ornament, Pillar
5 Modern Skyscraper
6 Place of Worship, Totem
7 Doorway, Archway
8 Old Village, Cottage

Two-Point Perspective

1. Begin with a simple horizon line, then place two vanishing points at either side along this line.

2. Sketch out a couple planes with straight vertical lines, then mark out the tops and bottoms of the boxes, extending to the left vanishing point.

3. Extend lines from the vertical lines to the right vanishing point to form the tops and bottoms of the other side of the boxes. The boxes now lie flat on the land.

1 SKETCHING IN PERSPECTIVE

Sketch in two-point perspective guidelines. Lightly sketch the main shapes of each building and the shapes that ornament each rooftop and dome. Then draw the windows, wooden beams, banisters and stairs. Slope the front tower to make the brick pattern look dramatic and strong.

2 ADDING DETAIL

Never be afraid to make details on top of your details—ornaments are supposed to be complex. Lightly refine each of the rooftops with bowl-shaped windows. Break each of the domes into segments. Add the pegs that shoot out from the center of the far tower. Sketch in the inner and outer ellipses of the archway, and break them into equal stones with lines shooting from the center point. Sketch in the crossbeams with mortised joints, and begin your brick pattern by drawing in equally spaced horizontal mortar guidelines from top to base.

Brick Pattern Closeup

Any brick wall finds its strength with its staggered bricks. Begin the brick wall with horizontal lines for each row. Break those horizontal lines into staggered vertical mortar guidelines that will follow the slope of the surface and bow out slightly.

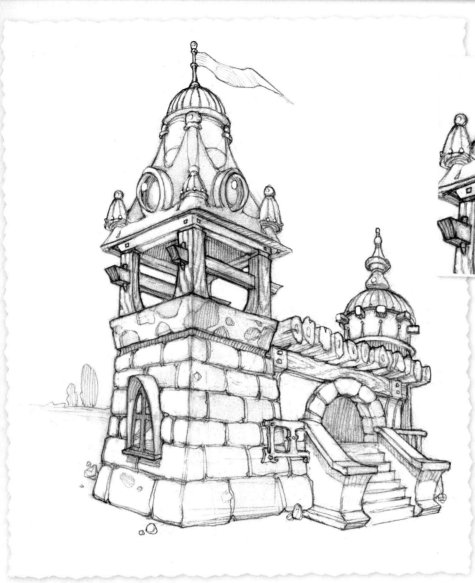

3 FINISHING

Finish the castle towers with shadows underneath the major forms and in between the gaps of bricks and lips of the domes. Add pegs and tiny hatching that curves over the wood, making the pattern of wood on the beams. Draw the hatch lines forming the thin and random chips in the plaster slab beneath the wooden beams. Darken the outlines defining each building, and erase the highlights on the tops of each brick, dome segment and every surface facing the sun.

Wood Hatching

When wood is cut into planks, it forms beautiful surface circlets and forms. I mimic this by drawing those shapes, then lightly hatching in the tiny lines that follow the direction of the planks.

TOOLS OF METAL

When we are toddlers, we start making and using tools. Even a smart monkey coaxes termites from his nest with a stick. The Tool rolls are unique in that each one has a handcraft and a number of associations linked with its function. Think about the forms and patterns of each Tool roll, but also the many ways each tool is used. Razor could produce a claw with razors or a creature whose fur has been shaved. You may want to use a Drill roll as a spiraling nose or a creature filled with drill holes along its arm. When I get the Hammer roll, one of my favorite associations is to make hammerhead shark protrusions on my creation's head or shoulders.

A Tool roll can add to your creature's form and surface, but we'll begin by exploring an assembly of several metal tools.

(3)

TOOL LIST
2d6 Roll

2 Drill
3 Cups, Plates
4 Umbrella
5 Bundle, Bale
6 Hammer, Axe
7 Brush – Hair, Tooth
8 Razor, Knife
9 Spigot, Faucet
10 Rope
11 Silverware
12 Lock, Key

(5)

TOOL LIST
2d6 Roll

2 Adhesive, Bandage
3 Shovel, Pick
4 Capsule, Tablet
5 Nuts, Bolts
6 Chain
7 Thread, Stitch
8 Shears, Scissors
9 Pen, Paintbrush
10 Spring, Coil
11 Syringe
12 Tube, Plumbing

SKETCHING

Begin your metal tool assembly with the centerline and guideline ellipses for the faucet and spigot. Sketch the box and handle shapes for the pickaxe. Then loosely draw a couple of curved lines to use as directional lines for your chain links.

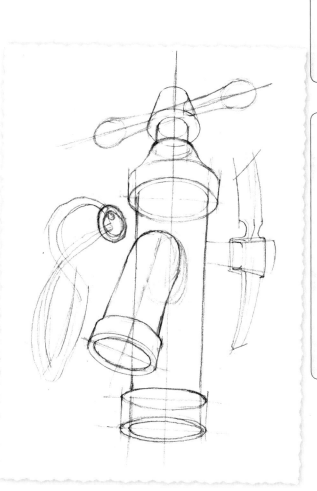

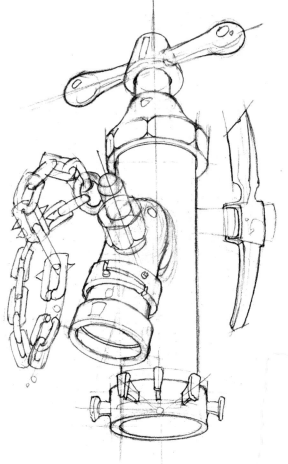

2 BEGINNING DETAILS

Sketch nails onto the bottom pipe fitting, making each nail sprout out from the center point inside the pipe. Both the faucet fitting and nut are put together with a flat wrench, so draw straight lines splitting their ellipses into six or eight flat sides. When drawing chain links, keep in mind that each link loops around the other, and decide how much it's being pulled or how slack it is. Here, the top chain links show a bit more of their shape, where the bottom links that are pulled tight are flat.

3 FINISHING

Draw the threads of the bolt and the wood pattern from the Wood, Stone and Mortar demonstration (see page 88) on the handle of the pickaxe. Then erase and refine the outlines, and add some shading inside and at the edges of the tubes.

You can make any surface look like metal through shine or rusty decay. Notice how the highlights on the faucet handle and rust spots on the pickaxe both indicate their metal makeup.

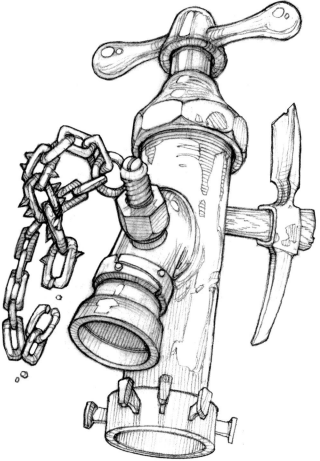

FABRIC AND FIBER

Now we'll try out a stitched bale-tail plushy doll made from a few fabric and fiber tools.

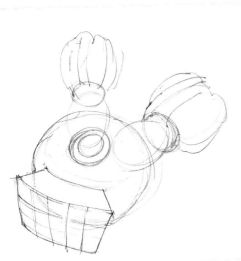

SKETCHING
Draw the main circle, button eye and shapes for the two haystack pigtail bales. Roughly sketch the curved box shape for the bristle brush teeth, and split that shape into three rows of boxes. Brushes normally have at least three rows of bristles, but you can split it up into however many teeth you like as long as they are in a grid pattern.

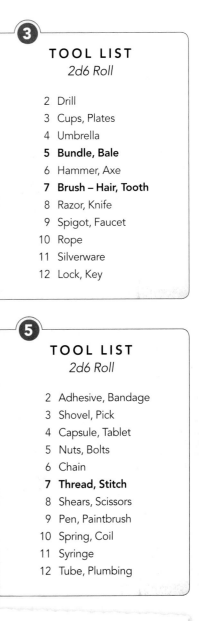

③

TOOL LIST
2d6 Roll

2 Drill
3 Cups, Plates
4 Umbrella
5 **Bundle, Bale**
6 Hammer, Axe
7 **Brush – Hair, Tooth**
8 Razor, Knife
9 Spigot, Faucet
10 Rope
11 Silverware
12 Lock, Key

⑤

TOOL LIST
2d6 Roll

2 Adhesive, Bandage
3 Shovel, Pick
4 Capsule, Tablet
5 Nuts, Bolts
6 Chain
7 **Thread, Stitch**
8 Shears, Scissors
9 Pen, Paintbrush
10 Spring, Coil
11 Syringe
12 Tube, Plumbing

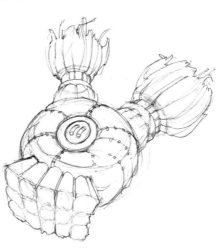

2 BEGINNING DETAILS
Add the secondary shapes of the plushy's bristle teeth by lightly sketching an ellipse inside and rounding each segment of the grid. Notice the diamond shapes in the gaps between the bristles; make each of those shadow areas. Randomly split up the different clumps of hay on the haystack pigtail bales and draw the bands that hold the bales. Notice that when the bands on hay slip, the hay retains the shape that the band made in the hay. Then begin the details of the button eye, and add guidelines for the stitching pattern, making sure the stitches are evenly spaced.

3 FINISHING
Erase and refine the outlines, and add tone and shadows to the forms. Add a few hairs around the bunches of bristles and a few stems of hay shooting out of the top of the bales to show what they are made of. Add shadows down around the button eye and around each stitch, making tiny stretch lines.

4 Machine :: 1d6

Look a couple feet away from where you're sketching, and you will find a machine that we use every day: a kitchen appliance, a windup toy, a calculator, a squirt bottle, a computer, a fan, an alarm clock. In fact, there are so many amazingly different connections and mental associations we can make in the realm of machines that it was split into a high-tech and a low-tech roll. The Machine roll is the world of high-tech rockets and gear-driven steampunk androids. When creating with the forms of machines, you could discover everything from dish antennas springing from the back of your creature's shell to laser-fingered humanoids. Imagine the pattern of exhaust vents or computer circuit control panels along the side of your Veggie or Anima creation, and you'll see just what the Machine Lists have to offer.

4

MACHINE LIST
1d6 Roll

1 Switch, Dial, Button
2 Turbine
3 Bulb, Lamp
4 Clock, Gears
5 Fan, Propeller
6 Saw

6

MACHINE LIST
1d8 Roll

1 Reactor Core
2 Telephone
3 Solar Panel
4 Engine
5 Laser Beam
6 Microchip
7 Dish, Antenna
8 Rocket

MECHS AND ANDROIDS

In this demonstration, we'll cover a couple different low-tech Machine rolls with a steampunk android I've created to help you explore the world of machines.

Gears

Gears can be thick or thin and can have as few as five teeth or as many as five hundred. As long as you make them fit together, they'll look believable. When making a gear, start with the center cross and the ellipses—one that faces you and another the same size to make its thickness. Split the face into equally spaced teeth in perspective (they get thinner on the right and left). Then draw lines down from the teeth to meet the other side of the gear.

④

MACHINE LIST
1d6 Roll

1 **Switch, Dial, Button**
2 Turbine
3 **Bulb, Lamp**
4 **Clock, Gears**
5 Fan, Propeller
6 Saw

⑥

MACHINE LIST
1d8 Roll

1 Reactor Core
2 Telephone
3 Solar Panel
4 **Engine**
5 Laser Beam
6 Microchip
7 Dish Antenna
8 Rocket

SKETCHING

Like in the transportation demonstrations, looking at insect anatomy helps when designing robots and androids. Start your android with the basic body guidelines and the shapes that form the head, neck and shoulders. Then draw the socket fittings that will hold the eye bubbles and brain case in place. Make sure there will be enough room on the socket fittings for the bolts.

2 BEGINNING DETAIL

Lightly sketch the guidelines for the bolts and screws just below the lip of the sockets, and mark out equally spaced screws around each one. Roughly sketch the centerline for each of the surrounding screws so that it shoots out from the center point of its ellipse. Draw the shapes for the lightbulbs inside the eye bubbles along the same centerline and add guidelines for the filament inside the bulbs. Then add the shapes for the face panel and nose dial, and lightly sketch in the guidelines for the gear shapes and body structure of its shoulders.

3 REFINING

Draw the spiraling filament inside the bulb eyeball and the ridges along the nose dial. Notice how the dial and gears are drawn the same basic way. I put a big crystal in the brain case, but why not roll to see what you put in there? Erase your guidelines, and refine the outlines around each assembly, nut and screw.

4 FINISHING

Steampunk machines often have bits of engraved leather or brass ornamenting them, and our android should be finished with a couple panel sections filled with engraving and some model numbers and letters. Rub tone into the shadow areas inside the eye bubbles and underneath the major forms. Darken the outlines and sketch hatch lines in the direction of the forms. Use your eraser to bring out the highlights in the shiny metallic android. Then it will be ready to engage your airship's steam engines with the turn of a dial.

EMOTION LIST :: 1D20 1D4

EMOTION LIST
1d20
1d4 Roll

2 Embarrassed
3 Anger
4 Timid, Bashful
5 Giggle, Smiling
6 Squint, Wink
7 Bored
8 Stressed, Fatigued
9 Fear
10 Thought, Meditation
11 Deadpan
12 Insane, Berserker
13 Insane, Happy
14 Pining, Furrowed
15 Laughing, Hysterical
16 Attentive, Shock
17 Stern, Grumpy
18 Clenched Teeth
19 Gape, Gawk
20 Relief
21 Sneering
22 Paranoid, Shifty
23 Bliss, Joy
24 Confusion

Emotion :: Our Inner Theater

As artists, we are given the opportunity to express ourselves through our creations. We can anthropomorphize any animal to smile with joy or well up with tears. We can become the actor or actress in our own play and portray expressions of every different emotion from the comfort of our own sketch. In the realm of fantasy, there are no boundaries to tie down these expressions, no laws of gravity or structure other than what we can make believable to the viewer. It is often what is seen in a character's expressions that impresses the viewer more than anything—the strong and stern visage of a warrior, the graceful brow of a feline creature, or the twisted and dark snarl of a villain.

Everything from the position of the ears and nostrils to the haircut design can affect the way your creation expresses emotion, but here we will concentrate on the eyes and brow line to show you five different general forms that you can use with the Emotion roll. Look back at the muscle structure of the face shown here if the shapes become confusing. And remember that female facial expressions will generally show little to no muscle definition, where male expressions will have much harsher lines and shadows.

Muscle Structure

Study the shapes and movements of the muscles in the human face. Muscles often move in tandem and affect other parts of the face—such as how the cheeks are affected by the movement of the mouth.

EMOTION PHOTO REFERENCE

Photo reference for emotion can be found just about everywhere, but stage and street actors and actresses are very good sources, as are movies. Look at the wide range of world cultures and their traditional actors, actresses and storytellers. Take pictures of your friends, and keep a small mirror at your drawing table to make your own expressions.

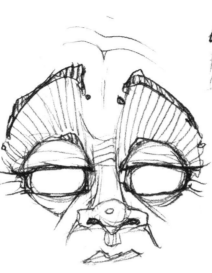

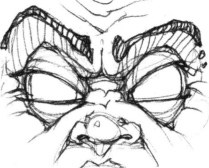

Wide-Eyed

The wide-eyed form can be used for the rolls: 11 Deadpan; 15 Laughing, Hysterical; 16 Attentive, Shock; and 19 Gape, Gawk. Your creation is very intense and surprised, staring into danger or fleeing from it.

Passive

The passive form can be used for the rolls: 5 Giggle, Smiling; 6 Squint, Wink; 7 Bored; 10 Thought, Meditation; 20 Relief; and 23 Bliss, Joy. Your creation will find itself calm, at ease and safe from life's worries.

Aggressive

The aggressive form can be used for the rolls: 3 Anger; 12 Insane, Berserker; 17 Stern, Grumpy; and 18 Clenched Teeth. Your creation will want to attack or defend. Don't get your fingers too close.

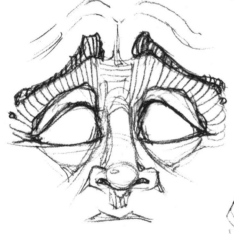

Inverted

The inverted form can be used for the rolls: 2 Embarrassed; 4 Timid, Bashful; 8 Stressed, Fatigued; 9 Fear; and 14 Pining, Furrowed. Your creation will be bursting into tears or be ready for a good night's sleep.

Staggered

The staggered form can be used for the rolls: 21 Sneering; 22 Paranoid, Shifty; and 24 Confusion. Your creation will tilt its head and wonder how you ever brought it into existence.

WIDE-EYED

The wide-eyed form is made with a lifted brow and by stretching both upper and lower eyelids all the way open. This combination will always make your character look surprised or panicked. Whether they are slack-jawed, screaming, pursing their lips, smiling or frowning, they will look to be in a state of shock. These expressions are great for prey, nervous and flighty herd animals, those caught in the headlights, or creations that have discovered a vast treasure.

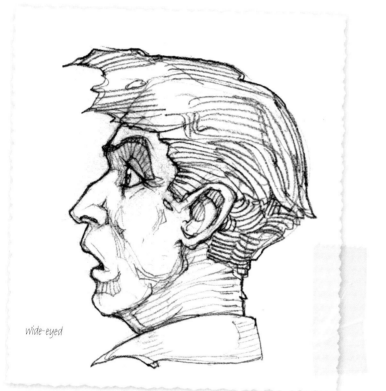

Wide-eyed

EMOTION LIST
1d20
1d4 Roll

2	Embarrassed
3	Anger
4	Timid, Bashful
5	Giggle, Smiling
6	Squint, Wink
7	Bored
8	Stressed, Fatigued
9	**Fear**
10	Thought, Meditation
11	**Deadpan**
12	Insane, Berserker
13	Insane, Happy
14	Pining, Furrowed
15	**Laughing, Hysterical**
16	**Attentive, Shock**
17	Stern, Grumpy
18	Clenched Teeth
19	**Gape, Gawk**
20	Relief
21	Sneering
22	Paranoid, Shifty
23	Bliss, Joy
24	Confusion

SKETCHING THE GESTURE

Begin with the gesture of expression. Lightly sketch in centerlines for her face and eyes. Draw the circle shapes of the eyeballs, and wrap her lash line shapes around them. Then sketch the raised brow, the tip of her nose and the gesture of her pursed lips. Keep plenty of room between the raised brow line and the eyeballs. Notice that the eyeballs sink back from the brow line, and the eyelids barely cover the circle shape of the eyeballs.

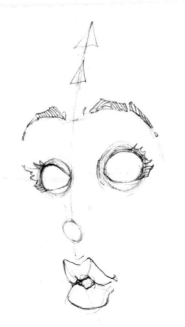

GESTURE OF EXPRESSION

Make your gesture drawings quick and expressive. Place the general direction of the eyebrows and lips, making sure the symmetry is correct.

2 BUILDING SECONDARY SHAPES

When the gesture is drawn, add the secondary shapes—her nostrils on either side of the tip, cheekbones, jawline and head. Draw the highlights, pupils and irises inside the eyeballs, taking care to keep some white area all the way around. Then sketch in directional wisp lines to form the design of her hair. Notice how the hairline can reinforce the same raised direction of her brow.

3 FINISHING

Draw the design of her hair, making sure to keep it just outside the guideline of her head. Shape the outline of the hair first, then split up the form into flowing, dynamic strands, mixing them into each other as you go. Intersecting strands always add an extra pattern of negative space to the hair. Sketch in the shadow areas, then darken your outlines. Erase your highlights, and keep the areas between the brow and eyes dark for her wide eyes to pop.

FEMALE FACES

When drawing a female character, keep in mind the oval and curving shapes in the face. The moment you add any hard angles to a female face it begins to look masculine. Keep the eyebrows thin and the curve of the jawline and cheeks spoon-shaped.

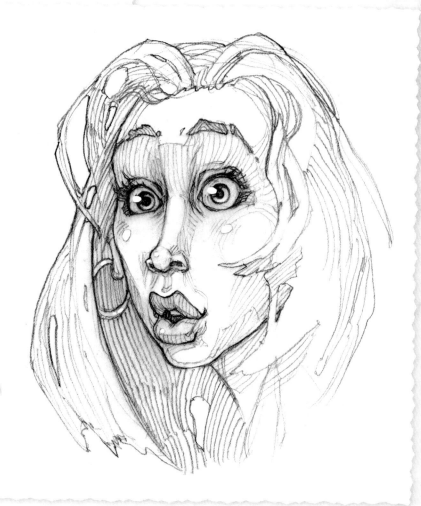

PASSIVE

The passive form is made with a lifted brow line and lowered eyelids. This combination will make your creation look relaxed, at ease or meditative. It can be used on any character—from a beast of burden showing a dumbfounded indifference to a stately and confident alien princess. Here we have an example of passive relief, which will show you the basics of making your creation calm, cool and collected.

EMOTION LIST
1d20
1d4 Roll

 2 Embarrassed
 3 Anger
 4 Timid, Bashful
 5 Giggle, Smiling
 6 Squint, Wink
 7 Bored
 8 Stressed, Fatigued
 9 Fear
10 Thought, Meditation
11 Deadpan
12 Insane, Berserker
13 Insane, Happy
14 Pining, Furrowed
15 Laughing, Hysterical
16 Attentive, Shock
17 Stern, Grumpy
18 Clenched Teeth
19 Gape, Gawk
20 Relief
21 Sneering
22 Paranoid, Shifty
23 Bliss, Joy
24 Confusion

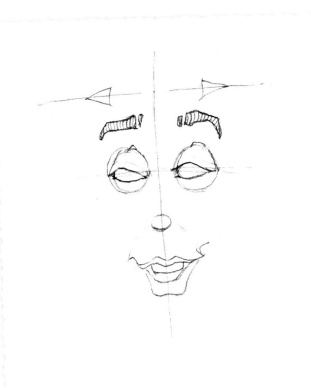

⏐ SKETCHING

Start with a centerline cross guideline and circle eyeball shapes. Lightly sketch the eyelid lines wrapped around the eye circles, making both upper and lower lids cover quite a bit of his eyes. Place the nose tip and gesture of his lips. Notice how this expression has a slight smile while in speech, so the upper teeth show, and the corners of the mouth shape are drawn up on the right slightly more than the left. Sketch in the raised brow, keeping each eyebrow flat.

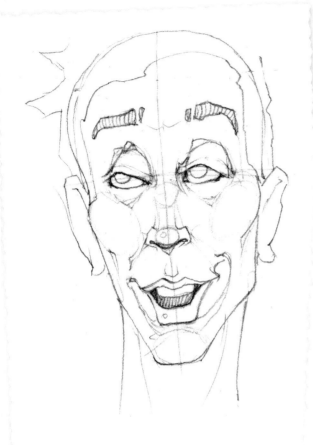

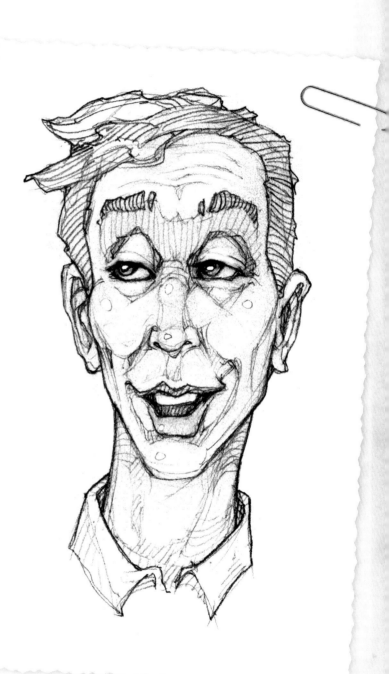

2 BEGINNING DETAIL

Draw secondary guidelines around the facial expression for the head, jawline and neck. Add a long brow line shadow area, deep eyelid outlines and high cheeks, lifting the corners of the mouth to form his relieved smile. Draw in the shape of each pupil, and make sure that the eyelids cover at least half of the eyeball shape.

3 FINISHING

Refine the outlines and shadows of the eyes, lashes and brow, making sure that the eyelids are lowered and heavy. Notice that the raised brow will make wrinkle lines in the forehead, and a smile will form deeper shadows underneath the nose and cheekbones. Darken the outlines, add hatch lines to the shadow areas underneath all the major forms and erase the highlights.

AGGRESSIVE

The aggressive form is made with a lowered and knitted brow that pushes the corners of the eyelids in a downward direction. You will also find lips peeled back from gritted and bared teeth, sharp ridges along the length of the nose, and flared nostrils. This combination will make your creation look angry and ready for the attack. It is the expression of the warrior and the predator, which strikes fear into your viewer. The aggressive expression is one of rage and can be used on anything from meaty soldier or flesh-eating zombie creature, to a tiny sparrow or Halloween pumpkin. In this demonstration we have an example of the Clenched Teeth roll, which will show you the basics of making your creation so angry that he's ready to explode with berserker rage.

SKETCHING

Draw cross guidelines and circle eyeball shapes. A meaty character like this one will benefit from smaller eyeballs and a huge brow. Lightly sketch the eyelid lines wrapped around the eye circles, bringing the lower lids halfway up the eyeball and the upper lids down in the same direction as the brows. Place the nose tip, the box of clenched teeth and the gesture of lips peeling back around them. Notice how the brow line drops to the same level as the eyes and is sharply creased down the center.

EMOTION LIST
1d20
1d4 Roll

 2 Embarrassed
 3 Anger
 4 Timid, Bashful
 5 Giggle, Smiling
 6 Squint, Wink
 7 Bored
 8 Stressed, Fatigued
 9 Fear
10 Thought, Meditation
11 Deadpan
12 Insane, Berserker
13 Insane, Happy
14 Pining, Furrowed
15 Laughing, Hysterical
16 Attentive, Shock
17 Stern, Grumpy
18 Clenched Teeth
19 Gape, Gawk
20 Relief
21 Sneering
22 Paranoid, Shifty
23 Bliss, Joy
24 Confusion

WRINKLES FOR EMOTION

The brow wrinkles formed by the angular head muscle between the nostrils and brow are often all it takes to make a character or creature look angry. This classic snarl hints at aggression in most predatory Anima.

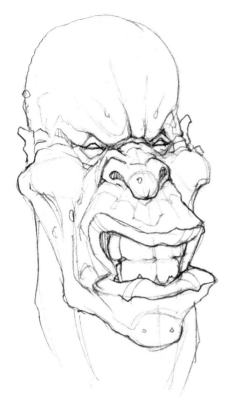

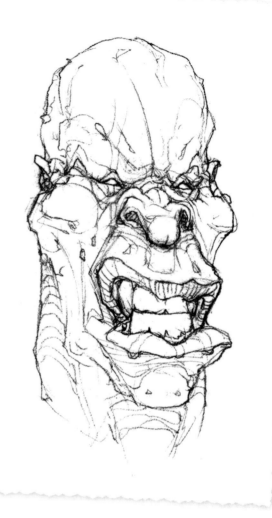

2 BEGINNING DETAIL

Draw in secondary shapes and guidelines around the facial expression. Draw the nostrils massive and flared, high cheek-bones and masseter (jaw muscle) bulging from the lower jaw. Sketch the wrinkles between the nostrils and brow. Notice how the skin wrinkles form around his eyes and brow. Draw gums and split some teeth with lines, but keep the solid white of his teeth a focal point.

3 FINISHING

Refine the outlines and shadows across his whole face. The white of the teeth, the flared nostrils and the beady wrinkled eyes will pop out as you darken the shadows around them. Add the detail of a scar line across his eye.

INVERTED

An inverted expression is made by lifting only the inner part of the brow line, with the eyelids drooping in the same direction. The placement of the lips can change everything about the inverted form; it has the potential to make your creation look anything from extremely scared to gently timid. With calm and lowered eyelids, the inverted expression can make your character look romantic and forlorn; with wider eyes, it can make your creature appear worried of an approaching attack. Here we have an example of a 4 Timid, Bashful roll, which will show you the basics of making your creations go a bit red in the cheeks.

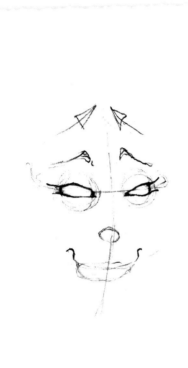

EMOTION LIST
1d20
1d4 Roll

2 **Embarrassed**
3 Anger
4 **Timid, Bashful**
5 Giggle, Smiling
6 **Squint, Wink**
7 Bored
8 **Stressed, Fatigued**
9 **Fear**
10 Thought, Meditation
11 Deadpan
12 Insane, Berserker
13 Insane, Happy
14 **Pining, Furrowed**
15 Laughing, Hysterical
16 Attentive, Shock
17 Stern, Grumpy
18 Clenched Teeth
19 Gape, Gawk
20 Relief
21 Sneering
22 Paranoid, Shifty
23 Bliss, Joy
24 Confusion

SKETCH

Sketch the cross guideline and circle eyeball shapes. Lightly sketch the eyelash lines wrapped around the circle orbit, making both upper and lower lids cover quite a bit of her eyes. Place the nose tip and gesture of her lips. Notice how this expression has a wide and curved smile, with corners that lift almost to the nose tip. Sketch in the Inverted brow line, raising only the inner tips of each eyebrow.

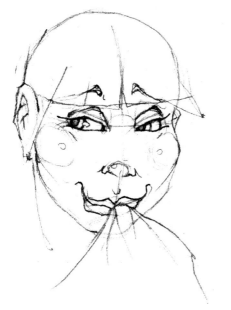

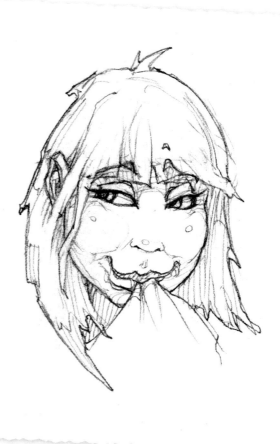

2 BEGINNING DETAIL

Draw in secondary guidelines around the facial expression for the head, high cheekbones, jawline and neck. Draw in the shape of each pupil, and make sure the eyelids cover most of the pupil shapes in a squint. Refine the curved lip lines, adding the hint of her hand gesture underneath a stretch of fabric.

3 FINISHING

Add wisps of hair around her head, and sketch in the shadow areas underneath the line of her bangs. Refine the outlines and shadows of the eyes, lashes, curved smile and brow, making sure that the inverted brows can be seen through her bangs. Darken the outlines, then erase the guidelines and highlights. Use only a few light lines to show the shadow of the wide cheeks, leaving only the bottom edge of the nose.

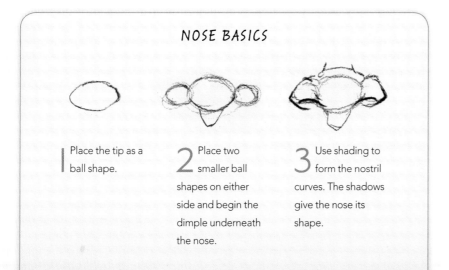

NOSE BASICS

1 Place the tip as a ball shape.

2 Place two smaller ball shapes on either side and begin the dimple underneath the nose.

3 Use shading to form the nostril curves. The shadows give the nose its shape.

STAGGERED

The staggered expression is made with one eyebrow lifted, the other lowered, and often with the eyelids raised or lowered in the same direction. The head will often be tilted or looking sidelong at the viewer or focal point. This combination will make your creation look confused and in doubt. It implies a sense of both intelligence and bewilderment when used on a creature. Or it can be used on a proud, noble character expressing his class, dominance or displeasure. Here we have an example of a staggered 21 Sneering roll, which will show you the basics of giving your creation a bit of an attitude.

SKETCHING

Draw the cross guideline tilted to the side and the circle eyeball shapes. Lightly sketch the eyelid lines wrapped around the eye circles, making both the upper and lower lids cover quite a bit of his eyes. Sketch in one raised and one lowered eyebrow as well as the tip of his nose and the pursed gesture of his lips.

EMOTION LIST
1d20
1d4 Roll

2 Embarrassed
3 Anger
4 Timid, Bashful
5 Giggle, Smiling
6 Squint, Wink
7 Bored
8 Stressed, Fatigued
9 Fear
10 Thought, Meditation
11 Deadpan
12 Insane, Berserker
13 Insane, Happy
14 Pining, Furrowed
15 Laughing, Hysterical
16 Attentive, Shock
17 Stern, Grumpy
18 Clenched Teeth
19 Gape, Gawk
20 Relief
21 Sneering
22 Paranoid, Shifty
23 Bliss, Joy
24 Confusion

2 BEGINNING DETAILS

Draw in secondary guidelines around the facial expression for the head, jawline and neck. Add deep eyelid outlines and the shape of each pupil. Make sure that the eyelids cover at least half of the pupil shape. A key element to any sneer is the slight curling of the upper lip. This is done by lifting one nostril up and drawing wrinkles between the nostril and lower eyelid. Notice the L-shaped wrinkles that the staggered brow line creates in his forehead.

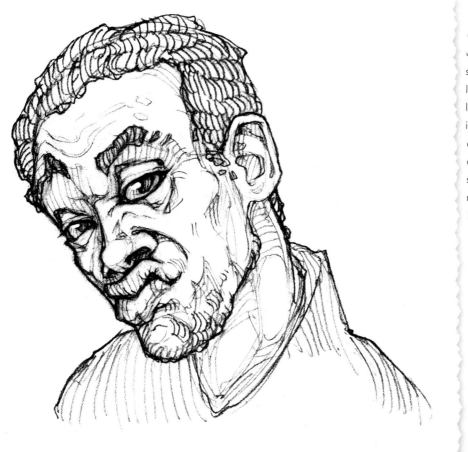

3 FINISHING

Refine the outlines and shadows of the nostrils and curled lip. Make sure that the eyelids are lowered and heavy and that there is a large shadow area beneath the one raised eyebrow. Darken the outlines, and add hatch lines to the shadow areas underneath all the major forms of the head and face. Erase the highlights.

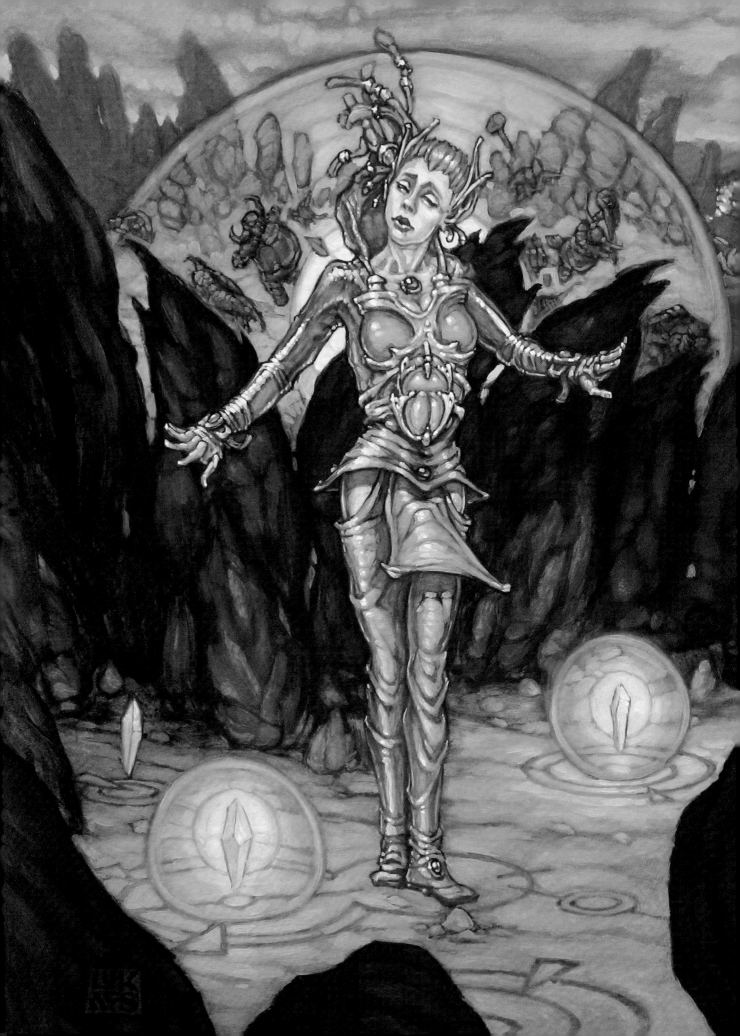

ACTION LIST :: 1D20 1D8

ACTION LIST
1d20
1d8 Roll

 2 Recoil, Akimbo
 3 Drenched, Thirst
 4 Blown by Cyclone
 5 Push, Pull
 6 Snoop, Listen
 7 Crouched for Attack
 8 Hang, Climb
 9 Recoil, Head/Torso
10 Float, Levitate
11 Swinging Weapon
12 Twisting, Stretching
13 Kicking, Punching
14 Squeeze, Tackle
15 Absorb, Eat
16 Limp, Injured
17 Curse, Swear
18 Run, Jump
19 Melt, Glow, Fire
20 Stuck, Trapped
21 Pull, Push
22 Shoot Weapon
23 Dying, Gaunt
24 Fly, Swim
25 Shed, Molting
26 Chant, Recite
27 Punch, Kick
28 Crawl, Emerge

Make It Move

Adding action to your creation will expand its character in amazingly fun and inventive ways. There are no limits to what an actor or actress can express with their body language, and the Action List is just as vast. The Action List might give your creation anything from a specific costume to an occupation or function, but at the very least it will get it moving about. When developing characters, the Action roll often expands your ideas so much that it's sometimes best to roll it first for a focus. Then, when you've already created a static object or creature design idea, you can roll the Action List to put it in a couple different poses and situations, making your creation much more believable and real.

Hunched or Crouched

In a classic hunched or crouched position, the shoulder blades are raised, placed below the spine and cast shadows on the back if it's visible.

Extend and Swoop

The extended arms of these lions convey both attack and recoil. Their swooping tails can also show the direction of their actions.

USING ACTION

Write a paragraph or two describing your creation and its action. It may turn into a whole story.

Shoulder and Hip Placement

One way to make any pose look more dynamic is to invert the hip line and shoulder line (note the gray lines in the illustrations) or align them along the same major direction of the force of action. This character's hips are inverted from her shoulder line, giving her attitude and the believability of weight displacement. Inversion of the shoulders and hips can be used very effectively for feminine characters and poses, whereas straight and square shoulders can show strength and are effective for masculine characters.

In either case, placement of shoulders and hips opposing or going with the major direction of your pose ads drama and flow to its action.

Shoulder and Hip Alignment

Notice in this pose the way both the shoulder and hip lines follow and reinforce the direction of the weapon handle. When you align the many lines of movement, you can direct the eye towards the focal point or action.

WIDE OPEN: THE OFFENSIVE, OUTSTRETCHED POSE

An offensive, outstretched pose has the limbs leading out from the body. The movement of the gesture is outstretched, making the shoulder and hip lines extend away from each other. Your creation is in control of its force. An outstretched focus will often be at the end of one of the limbs, and shoulder and hip lines will often be inverted. Here we see a jungle humanoid outstretched to reach for the next vine. We will use him to show the long flowing gestures that can be achieved in making your creation hang or climb.

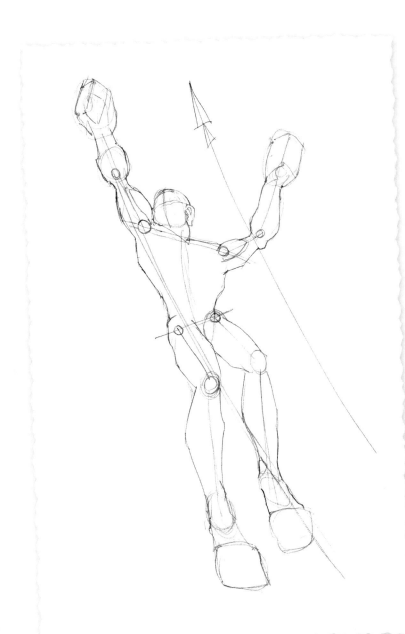

ACTION LIST
1d20
1d8 Roll

2 Recoil, Akimbo
3 Drenched, Thirst
4 Blown by Cyclone
5 Push, Pull
6 Snoop, Listen
7 Crouched for Attack
8 Hang, Climb
9 Recoil, Head/Torso
10 Float, Levitate
11 Swinging Weapon
12 Twisting, Stretching
13 Kicking, Punching
14 Squeeze, Tackle
15 Absorb, Eat
16 Limp, Injured
17 Curse, Swear
18 Run, Jump
19 Melt, Glow, Fire
20 Stuck, Trapped
21 Pull, Push
22 Shoot Weapon
23 Dying, Gaunt
24 Fly, Swim
25 Shed, Molting
26 Chant, Recite
27 Punch, Kick
28 Crawl, Emerge

SKETCHING

Lightly sketch gesture guidelines to show the upward flow of action. Add the inverted shoulder and hip lines, the circle points of each joint, and the body shapes and leg guidelines that stretch out from the body. Keep in mind the upward force of his right arm and the exaggerated shapes and length of all his limbs.

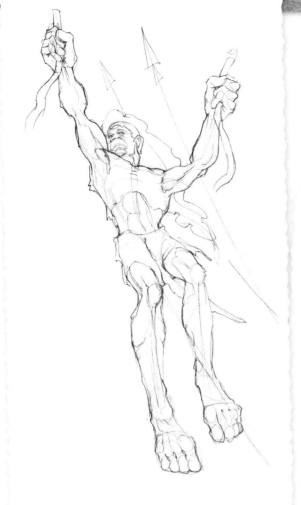

2 BEGINNING DETAIL
Start the secondary muscle shapes of the body along the guidelines. Form his rib cage in the same direction as his shoulder line, and wrap the joints and fingers of each foot and hand inside the boxed-out guidelines. Sketch facial details and hair, ensuring that the direction of hair follows the upward gesture guideline.

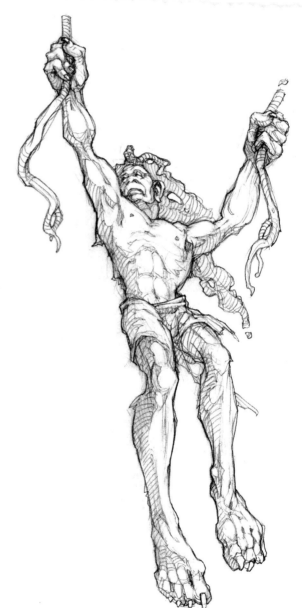

REFERENCE FOR ACTION POSES

For reference on action poses, look at the martial arts, sports and Olympic games. The poses of weight lifting, kickboxing, basketball, gymnastics and underwater shots can cover many poses of human anatomy and action that are rarely seen in day-to-day life, but have the lighting and detail to make your creation quite believable. Another good source is theater and movies. Real-life stunts and fighting sequences can show the dynamics of force and reaction, and the exaggerated poses of theatrical productions can show the more delicate actions.

For animal poses, look at zoos, zoological societies and rare animal sanctuaries. Animals are amazingly versed in body language; good reactions can sometimes be caught in youngsters, and underwater shots of land animals can show them in positions never seen on land.

3 FINISHING
Refine the details of anatomy, and map the shadows around all the anatomical forms. Notice the details of frayed fabric, and how it accentuates the upward action. Erase guidelines and highlight details and darken in your outlines, adding small wisps of hair along the arm and leg joints.

CROUCHED AND CURVED: THE OFFENSIVE, COMPRESSED POSE

An offensive, compressed pose has the limbs and spine curved inward together. The movement of the gesture is compressed, making the body, shoulder and hip lines crimped close to each other. Your creation is in control of its force. This pose of the body is often found in the behavior of animals and creatures, so in this 5 Push, Pull demonstration we will use the example of a wolf pulling with his head and teeth. His back is arched up and his limbs are pointed inward as he uses his weight to pull in his prey.

BEHAVIORAL TIP

Animals often pull their ears back and curl their tail in a move of involuntary protection. They also raise their fur when afraid or ready to strike to make themselves look larger. Notice how this wolf's ears curve around to the back of his raised hackle fur.

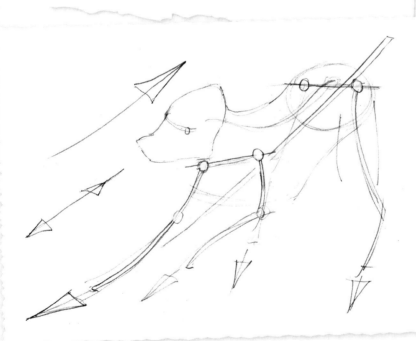

SKETCHING THE GESTURE

Start the pulling action by lightly sketching gesture guidelines to show the flow of action. Draw the shoulder and hip lines, the circle points of each joint, and the body shapes and leg guidelines that stem from them. Keep in mind the downward force of the legs and arching of the spine.

ACTION LIST
1d20
1d8 Roll

2 Recoil, Akimbo
3 Drenched, Thirst
4 Blown by Cyclone
5 Push, Pull
6 Snoop, Listen
7 Crouched for Attack
8 Hang, Climb
9 Recoil, Head/Torso
10 Float, Levitate
11 Swinging Weapon
12 Twisting, Stretching
13 Kicking, Punching
14 Squeeze, Tackle
15 Absorb, Eat
16 Limp, Injured
17 Curse, Swear
18 Run, Jump
19 Melt, Glow, Fire
20 Stuck, Trapped
21 Pull, Push
22 Shoot Weapon
23 Dying, Gaunt
24 Fly, Swim
25 Shed, Molting
26 Chant, Recite
27 Punch, Kick
28 Crawl, Emerge

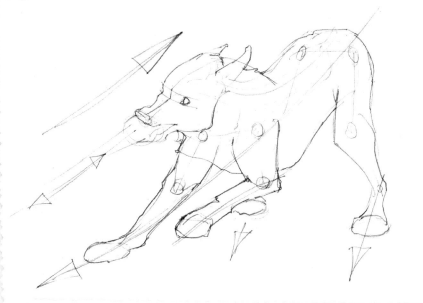

2 ADDING THE SHAPES

Add the shapes of the body, head, legs and paws along your guidelines. Sketch the wolf's maw and anchor the bit of meat he's pulling with a straight and taut guideline. Make sure the gesture is following the flow of action. Begin to outline the details around the whole body, locking in the action.

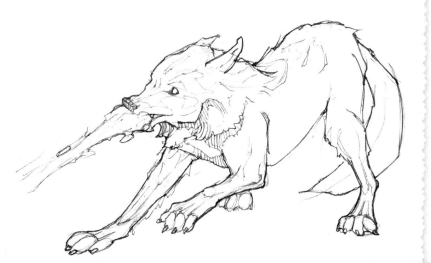

3 BEGINNING DETAILS

Draw in the secondary muscle shapes of the paws and claws and legs (see page 41). Erase the movement guidelines and refine the details of the wolf's face and maw, adding the wrinkles along his snout and tail, and bits of meat stretching as he pulls.

4 FINISHING

Refine the outlines of the body with jagged fur and hatch lines in shadow areas between and underneath all the forms. Darken the outlines of his fur and the shadows of the nose and maw.

INVISIBLE FORCE: THE PASSIVE POSE

The passive pose is a reaction to an outside force, which will move a character's whole body outside its own accord. It puts the body into a position of weightlessness. The movement of the gesture is great to use with mystical events and zero gravity. Your creation could be flying a wave of glowing magic, blown by heavy winds or even suited up like an astronaut. The fingers, paws or toes of your creation will often be extended away from each other, not touching any surface or ground. This demonstration will show you how the 10 Float, Levitate roll can be used in your magical creations with the help of a superheroine gliding on invisible winds.

ACTION LIST
1d20
1d8 Roll

 2 **Recoil, Akimbo**
 3 Drenched, Thirst
 4 **Blown by Cyclone**
 5 Push, Pull
 6 Snoop, Listen
 7 Crouched for Attack
 8 Hang, Climb
 9 Recoil, Head/Torso
10 **Float, Levitate**
11 Swinging Weapon
12 Twisting, Stretching
13 Kicking, Punching
14 Squeeze, Tackle
15 Absorb, Eat
16 Limp, Injured
17 Curse, Swear
18 **Run, Jump**
19 Melt, Glow, Fire
20 Stuck, Trapped
21 Pull, Push
22 Shoot Weapon
23 Dying, Gaunt
24 **Fly, Swim**
25 Shed, Molting
26 Chant, Recite
27 Punch, Kick
28 Crawl, Emerge

SKETCHING

Lightly sketch the gesture guidelines to show the upward flow of action from head to shoulder and through her outstretched arms. Draw in the circle points of her joints and the inverted shoulder and hip guidelines. Then roughly sketch the basic body shapes along those guidelines. Keep in mind the force from below, and the movement of her arms, hips and shoulders as they will be the main dynamics of her pose.

2 BEGINNING DETAIL

Sketch in the various muscle shapes of her head, torso, arms and legs, and start to map out the shadow areas between and underneath those shapes. Sketch her hair and leg ribbons with flowing lines that flex and curl in the same upward direction as the gesture. Refine the gesture, making it follow the flow of action. Begin to outline the details around the whole body, locking in the action. To give the heroine an air of grace and confidence, pay special attention to her fingers and toes, making sure they are thin and move along with the flow of the gesture guidelines.

3 FINISHING

Refine and shade her facial features and costume details. Darken the outlines, rub tone and add shading into the shadow areas between and underneath all her muscle forms.

THINGS YET THOUGHT

The Object & Weapon Game is the cornerstone of *Fantasy Genesis*. The idea is to come up with two or three simple words you've never seen placed together that will spin brand-new forms and patterns into your imagination. The two rolls you pick can be used as a jumping point to create a mash-up of form and pattern, or something extraordinary and poetic from associating different meanings of the words.

Since there is nothing describing what you create besides the word *object*, your creation and its limitations of form and association are completely up to you. I use the Object & Weapon Game as a daily sketching exercise and keep the things I create in my sketchbook for future projects. The objects I create can someday turn into the hilt of a sword, a portion of armor or a costume. The association of these words can produce everything from a street lamp to a space station, but often I don't really know what I'm creating at the time! If you feel like practicing with something purely mechanical, choose both Techne rolls, or mash up both Anima and Techne rolls to get something more biomechanical. Have fun with your rolls. Practice drawing the parts and surface patterns of your new objects, and remember that you don't need to know what they are.

> ## BASIC DRAWING REVIEW
>
> *Remember that caterpillar bodies are segmented and sometimes hairy. Here is a list of pages you might want to review for the Object & Weapon Game: 26, 85, 87, 91, 93.*

Biomech
For this creature and his gun, I used Telephone for the major form and Pine (bark) for the minor form.

OBJECT & WEAPON GAME SHEET

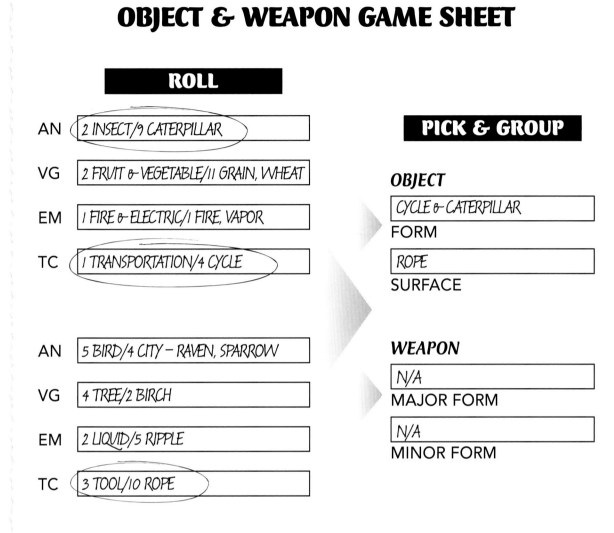

ROLL

AN (2 INSECT/9 CATERPILLAR)

VG 2 FRUIT & VEGETABLE/11 GRAIN, WHEAT

EM 1 FIRE & ELECTRIC/1 FIRE, VAPOR

TC (1 TRANSPORTATION/4 CYCLE)

AN 5 BIRD/4 CITY – RAVEN, SPARROW

VG 4 TREE/2 BIRCH

EM 2 LIQUID/5 RIPPLE

TC (3 TOOL/10 ROPE)

PICK & GROUP

OBJECT

CYCLE & CATERPILLAR
FORM

ROPE
SURFACE

WEAPON

N/A
MAJOR FORM

N/A
MINOR FORM

ROLL

First roll the indicated dice for the Set roll, then follow up with the appropriate List. Fill in the appropriate boxes on your game sheet.

PICK & GROUP

Cycle, Caterpillar and Rope were the rolls I picked for this object. The general idea began shaping itself as the mufflers and engine block of a motorcycle. Although as I sketched in elements of a soft caterpillar body, it slowly took the shape of a biomechanical vent or backpack filter. In this demonstration we'll sketch this biomech backpack to show one of the infinite number of objects you can create and use with other characters and creations.

REPETITION IS THE KEY TO MECHANICAL OBJECTS

When creating mechanical objects or their forms on something organic, keep repetition in mind. Line up a bunch of different forms in a row or around a circle or semicircle. One buckle looks good, but a row of them in sequential sizes looks awesome! If you're drawing a moving object, keep all the forms the same size and the same number and symmetrical from the left side to the right.

SKETCHING THE BASIC FORMS

Lightly draw the elliptical guidelines that define the shape and size of the object. Then draw a centerline down the tops of the shapes. The bottommost shape will be the manifold for the pipes to connect to.

2 ADDING DETAIL

Sketch the six long muffler shapes and the ellipse guidelines where they attach; make both left and right muffler shapes the same sizes and lengths. Notice how the four on top show their whole length and the other two will be covered. Roughly sketch in the secondary caterpillar body shape and head details.

3 REFINING DETAILS

Break the ends of all six pipes into the bubblelike cap forms. Draw through each of them, as they'll be transparent when you finish. Sketch a lip around each of the pipes as they fit into the manifold head, and begin to refine some of the details, keeping everything symmetrical on the left and right sides. Draw in the details of the caterpillar body, adding little fingertip warts to the segments. Draw in the guidelines for the body pattern along the centerline, and begin mapping out the shadow areas underneath each segment.

4 FINISHING

Darken the outlines around each form and add symmetrical details along the pipes and manifold head. Remember that metal parts look more believable when they are shiny. Each of the pipe fittings should have its own spot highlight, and each tube should have its own long bright highlight to show the difference in material from the main caterpillar body form. Erase the guidelines and fill in the shadow areas with tone and hatch lines. Perhaps you can then draw a space traveler to tell us exactly which way to put this thing on.

INSTANT EVOLUTION

Creatures of all varieties have fascinated me throughout my life. They are what lurk behind the shadows and what come to us as spirit guides. Both a part of us and separate, they show us the more natural and difficult aspects of life away from civilization and give us reason to conserve our common habitats. The concepts you create here may give you the inspiration to draw a species of creature that's never been thought of. Imagination has been the source of wonderfully diverse dragons and beasties of all kinds, and I just know your imagination will invent millions more!

The Creature Game has an extra Anima roll so that there's a large variety of Anima combinations and ideas you might find. When exploring your List for the Creature Game, think of how many legs and arms might fit and how your creature moves and eats in its habitat. Keep in mind what size and scale you'd like to make your creature. Will it be as big as a jet plane or no bigger than a parasite? Play around with breaking each of the words on your list into a body part. Make each part smaller or larger than it is in reality and test the boundaries of believability of what makes an animal an animal.

Ask yourself if your creature would make a good predator with a massive maw of teeth and long claws, or do your ideas center on a cute, fuzzy pet or herd animal with protective and defensive armor? Remember there are no rules for Pick & Group. Your creatures don't have to look like the animals you roll at all. If you want your creature to have feathered wings, give it wings, and see if another roll would make a nice surface pattern for them.

CREATURE GAME SHEET

ROLL

AN | 1 SEA LIFE/9 SHELL
AN | 4 REPTILE/2 FROG, NEWT
VG | 1 PLANT/9 GRASS, DANDELION
EM | 3 EARTH & METAL/3 MOUNTAIN, CLIFF FACE
TC | 2 ARCHITECTURE/6 PLACE OF WORSHIP, TOTEM
AN | 3 MAMMAL/2 MOUSE, RABBIT
VG | 1 PLANT/7 VINE
EM | 3 EARTH & METAL/10 SLATE, SHALE
TC | 3 TOOL/6 HAMMER, AXE

PICK & GROUP

FROG
MAJOR FORM

MOUSE
MINOR FORM

SLATE/SHALE
SURFACE

7 CROUCHED FOR ATTACK
ACTION

Sample Combination: Rock Rodent

This quick sketch was done after rolling Slate, Frog and Mouse. Notice how by making his legs and fingers long and froglike, I made this creature look rather small. With the addition of slate spinal spikes as defense, he ends up looking more prey than predator.

CREATURE GAME SHEET

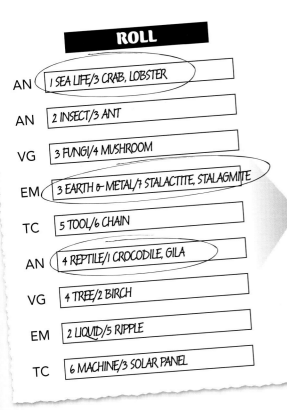

ROLL

AN — *1 SEA LIFE/3 CRAB, LOBSTER*

AN — *2 INSECT/3 ANT*

VG — *3 FUNGI/4 MUSHROOM*

EM — *3 EARTH & METAL/7 STALACTITE, STALAGMITE*

TC — *5 TOOL/6 CHAIN*

AN — *4 REPTILE/1 CROCODILE, GILA*

VG — *4 TREE/2 BIRCH*

EM — *2 LIQUID/5 RIPPLE*

TC — *6 MACHINE/3 SOLAR PANEL*

PICK & GROUP

CRAB, LOBSTER
MAJOR FORM

CROCODILE, GILA
MINOR FORM

STALACTITE
SURFACE

23 DYING, GAUNT
ACTION

Sample Combination: Sea Titan

This Sea Titan creature came about by mixing Sea Life and Reptile rolls for the form. Then, when drawing the face, I added the texture of rocky stalactites across its lips and forehead, making it look very wrinkled and ancient.

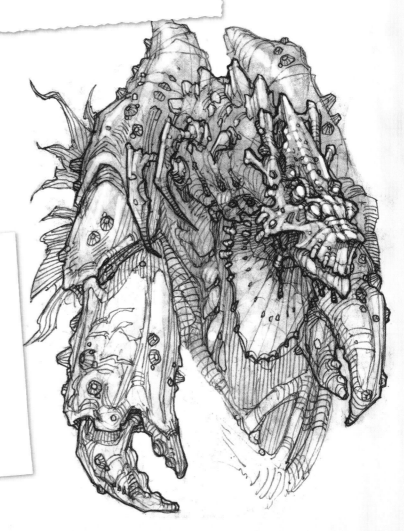

CREATURE CLIMATE CONTROL

Keep in mind if your creatures' habitat might be warm or freezing. Tropical creatures will generally be more lean and sleek. They have wrinkled skin and little to no fur, and they might spend a good amount of time underground or in the water. Creatures that live in snowy climates will have masses of white fur covering most of their bodies and will generally be a little plumper to hold in body heat.

CREATURE GAME SHEET

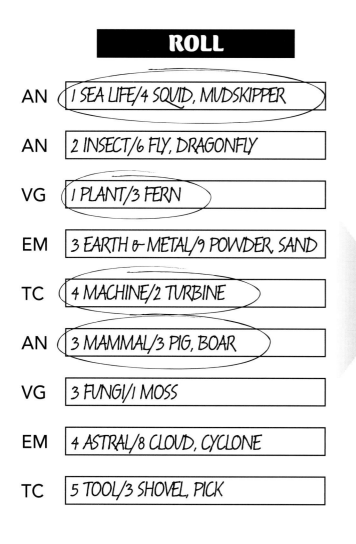

ROLL

AN — 1 SEA LIFE/4 SQUID, MUDSKIPPER

AN — 2 INSECT/6 FLY, DRAGONFLY

VG — 1 PLANT/3 FERN

EM — 3 EARTH & METAL/9 POWDER, SAND

TC — 4 MACHINE/2 TURBINE

AN — 3 MAMMAL/3 PIG, BOAR

VG — 3 FUNGI/1 MOSS

EM — 4 ASTRAL/8 CLOUD, CYCLONE

TC — 5 TOOL/3 SHOVEL, PICK

PICK & GROUP

BOAR, SQUID
MAJOR FORM

SQUID, FLY
MINOR FORM

TURBINE, FERN
SURFACE

24 FLY, SWIM
ACTION

ROLL

For this demonstration I rolled some nice combinations that produced a wide variety of creatures.

BASIC DRAWING REVIEW

Here is a list of pages you might want to review for the Creature Game: 17, 20, 21, 22, 28, 36, 58, 59, 87.

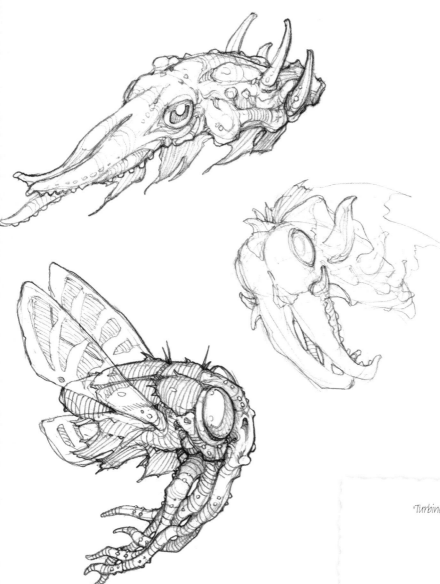

PICK & GROUP

After rolling Boar, Fly and Squid, I got the idea of two midsized creatures with bulgy eyes—one a flying Lovecraftian "Cthufly" and the other a swimming tusked sea creature. Then I wanted to explore a quadruped predator by switching the same rolls around a bit and playing with poetic word associations. Notice how completely different placements and results are possible with the same couple of words, and how a Turbine role might just turn into a Turban roll that ends up on your creature's head! Have fun re-creating this alien warthog creature in the next demo, and feel free to find a couple other evolutionary adaptations as you sketch.

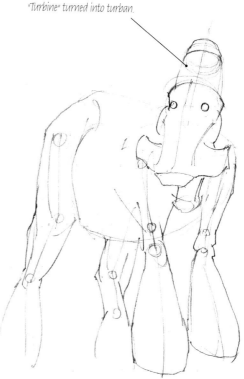

"Turbine" turned into turban.

SKETCHING

Lightly block out the basic shapes of his body, and sketch the guidelines and circle joints of the front and hind legs. The hind legs will just fade off down a hill, so they will appear shorter. Draw in the guidelines and centerline forming his head and the major shapes including his "turbine turban" and long boar snout.

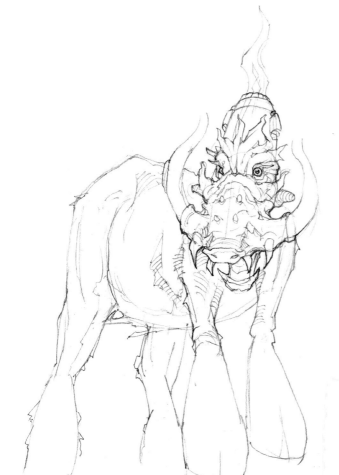

2 BEGINNING DETAILS

Sketch in the various wrinkles, warts and details of his head, body, arms and legs. Define the wide eyeballs, open jaws and aggressive brow. Begin to outline the details around the whole body, locking in the general pose. Notice at this stage that the warthog looks larger and elephant-like without the details of the horn tentacles and limb spikes added.

3 COMBINING DIFFERENT CHARACTERISTICS

Refine the details of the Squid and Fly characteristics on the warthog by drawing horn tentacles and limb spikes. The tentacles alone will make your creature look believably alien, and the hairy spikes along the legs give him insectlike elements. Erase the guidelines and darken the outlines, adding tufts of hair along the limbs and ridge of the back. Map out where the shadow areas might fall, and fill in those areas with tone or hatch lines.

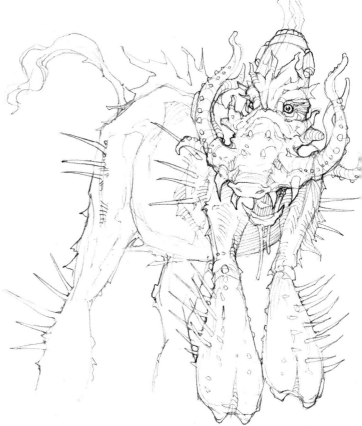

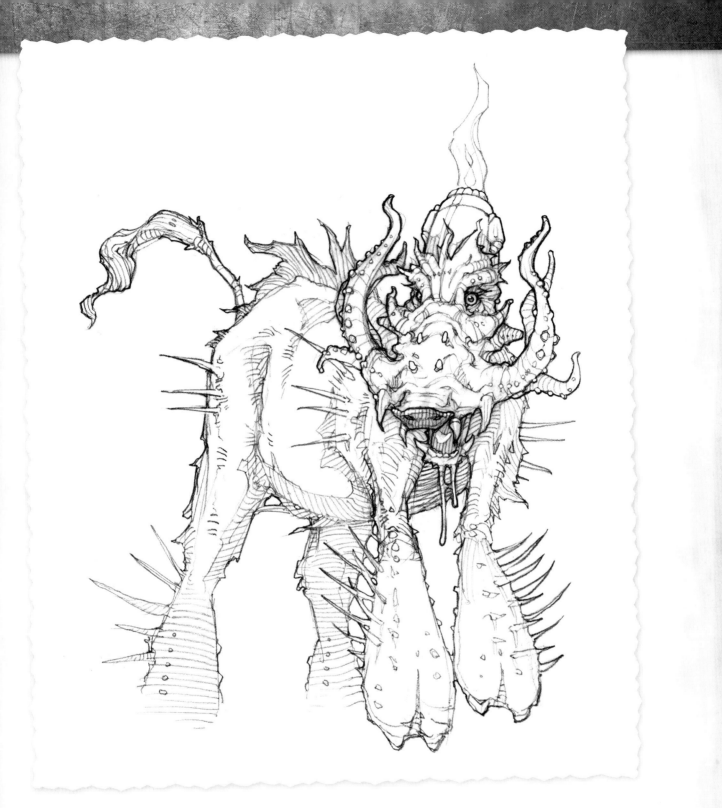

FINISHING

4 Fill in all the shadow areas underneath and between the alien warthog's many shapes and forms. Make sure you have a sharp pencil for hatch lines and tiny details. Darken the outlines around his body and limbs, paying special attention to the tentacles and head to separate the form to the front. Use the repetition of tiny tentacle warts and their highlights to draw the viewer's eye to the face. Also darken the nose, teeth and dripping jawline to bring them closer. Lastly, erase highlights into the tone and shadow of your creature.

WE'RE ONLY HUMAN

Get your pencils sharpened, fantasy geneticist! It's finally time to use all your descriptive words and let your imagination explore their infinite potential. The characters and concepts you create here may go on to inspire a whole series of sketches, paintings or stories based on the combinations you'll find.

It's a good idea to begin with rolls from the Emotion and Action Lists. Use the head and torso to give yourself a starting point, but then all bets are off. Freely associate and replace body parts, forms and surface textures. Test the limits of human anatomy. There's no need to make your drawing exactly like a human being. Let your creation take shape with as many faces, fingers, wings, fins, roots and rocks as you want—or perhaps use none at all. When playing the Humanoid Game, keep in mind all the different parts of each roll as well as their functions and positions. If you roll a Crab, think of its hard shell, pincers and stalky black eyes, where those parts might be placed and how they will move about. Think of how smart your creations might be and what kind of culture they could develop. Make new tasks for your humanoid, and expand on how your mutant creation might live and breathe, move and build things. The combination of Whale and Crater could bring your creation a series of crater-blowholes on its chest. Chainlike tentacles might wriggle from the legs of a creation made from the rolls of Octopus and Chain.

The Humanoid Game has been the source for many of my best creations. A flurry of brilliantly odd connections awaits your brain. I can't wait to see what you come up with!

> ## BASIC DRAWING REVIEW
>
> Here is a list of pages you might want to review for the Humanoid Game in general: 38, 41, 78, 91, 92, 110, 115, 116, 118, 120, 121.

HUMANOID GAME SHEET

ROLL

PICK & GROUP

ROLL

Fill in the Humanoid Game Sheet as you move through the Sets. In addition, you can roll from the Emotion and Action Lists.

	ROLL
AN	6 MAMMAL/2 BEAR
AN	1 SEA LIFE/4 SQUID, MUDSKIPPER
VG	1 PLANT/11 FLOWER – WILD
EM	3 EARTH & METAL/4 BRICK, COBBLESTONE
TC	5 TOOL/6 CHAIN
AN	2 INSECT/6 FLY, DRAGONFLY
VG	4 TREE/2 BIRCH
EM	2 LIQUID/6 FROST, SNOW
TC	1 TRANSPORTATION/6 BOAT, SHIP

BEAR
MAJOR FORM

FROST, SNOW
MINOR FORM

SQUID, FLY
SURFACE

11 SWINGING WEAPON
ACTION

17 STERN, GRUMPY
EMOTION

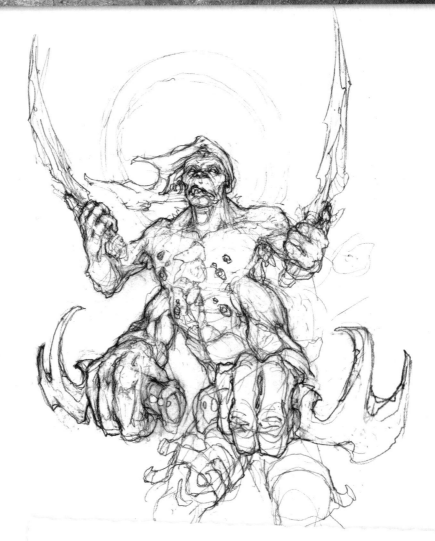

PICK & GROUP

For this demonstration I picked Bear, Frost, Snow and Swing Weapon from my rolls. This gave me the idea of a polar bear humanoid and then a multilimbed arctic snowman that I sketched. Then my idea became an icicle-wielding female Wendigo warrior of the same species I'd just created. Have fun recreating this Wendigo warrior character, and see if you can Pick & Group different associations on the rolls I got as you draw.

SKETCHING GUIDELINES AND BASIC SHAPES

Lightly sketch gesture guidelines to show the upward tilt of the weapon and outstretched arms, the direction of her head and shoulders, and the curve of her spine. Draw in the circle points of her many joints and the guidelines forming the lengths of her arms and legs. Then roughly sketch the basic body shapes along those guidelines, blocking out the position and shape of her hands and feet. Keep in mind the icicle spear on her back and the movement of her shoulders, arms and claws, as they will be the main dynamics of her pose.

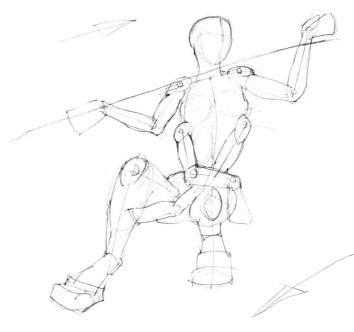

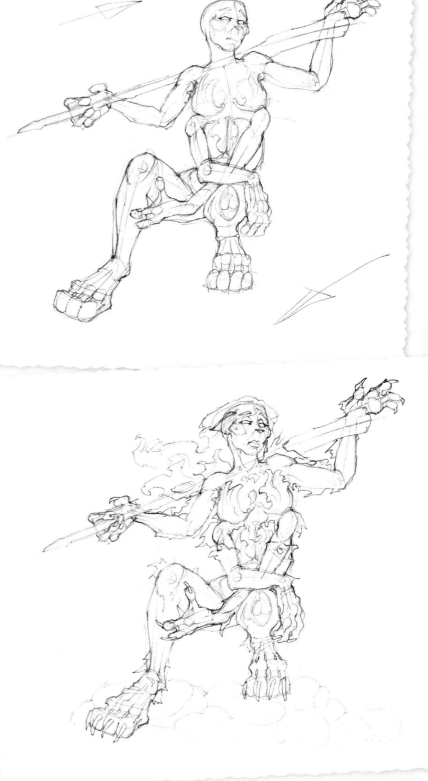

2 REFINING THE SHAPES

Sketch in the various muscle shapes of her head, torso, arms and legs. Draw the limbs in front first to save time in making details that you might erase. Begin to outline the details around the whole body, locking in the pose. Then refine the fingers and toes of the blocked out hands and feet. Make both left and right digits the same size and lengths.

3 BUILDING THE FEATURES

Draw the claws on each of the Wendigo's toes and fingers. Bear claws are much longer than many mammalian claws, but on a human-oid, nails and claws should seem a believable length so they can be used functionally. Place swirling guidelines for her hair outside the shape of her head, and sketch more detail into her stern expression. Draw the details of her ears, nose and snout that make her more believably bearlike. Erase the guidelines and highlight details, and darken the outlines, adding little tufts of hair along the arm, leg and finger joints where they bend.

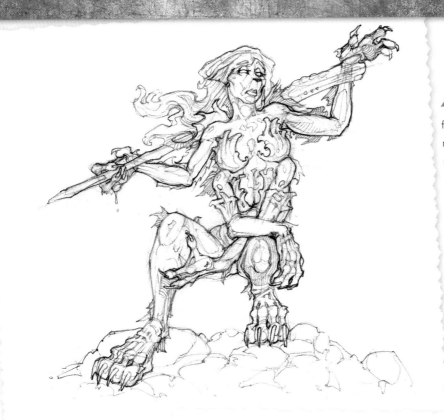

4 CREATING THE ENVIRONMENT

Begin a foreground of clumpy snow for the Wendigo to stand on, and lightly map out your shadow areas between and underneath all the forms and shapes. Refine her anatomy as well as the tendon and vein details of her claws and her icy costuming. Notice how the shadow of her upper claws shows through the icicle weapon giving it transparency.

5 FINISHING

Make sure you have a sharp pencil, and refine and shade her facial features and costume details. Erase and refine the outlines, lightly rubbing tone and adding shading into the shadow areas between and underneath all her muscle forms. Then erase highlights into the tone and shadow, keeping in mind that the light source should be coming from the right front.

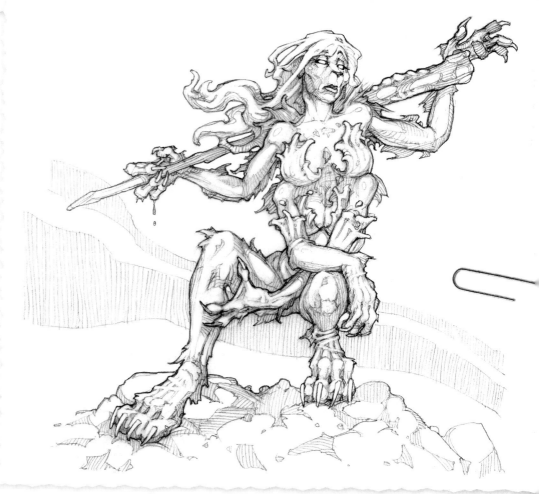

Game Sheets

BASIC GAME SHEET

ROLL

AN _____

VG _____

EM _____

TC _____

AN _____

VG _____

EM _____

TC _____

PICK & GROUP

MAJOR FORM

MINOR FORM

OBJECT & WEAPON GAME SHEET

ROLL

AN

VG

EM

TC

AN

VG

EM

TC

PICK & GROUP

OBJECT

FORM

SURFACE

WEAPON

MAJOR FORM

MINOR FORM

CREATURE GAME SHEET

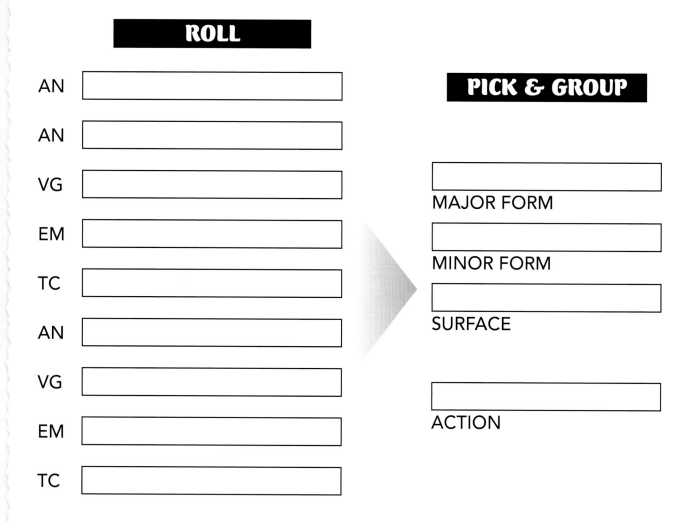

ROLL

AN

AN

VG

EM

TC

AN

VG

EM

TC

PICK & GROUP

MAJOR FORM

MINOR FORM

SURFACE

ACTION

HUMANOID GAME SHEET

ROLL

AN

AN

VG

EM

TC

AN

VG

EM

TC

PICK & GROUP

MAJOR FORM

MINOR FORM

SURFACE

ACTION

EMOTION

Index

If you're going to draw, draw with *IMPACT*!

Wreaking Havoc is a no-holds-barred guide to creating fantasy warriors and their offensive and defensive weaponry. You'll find advice and instruction on everything from drawing and painting techniques to the kinds of materials to use. 15 full demonstrations, 39 mini-demonstrations, 10 full-spread battle scene paintings and a bonus gallery of the authors' recent work offer a veritable arsenal of possibilities.

ISBN-13: 978-1-60061-000-4
ISBN-10: 1-60061-000-5
paperback, 128 pages, #Z0989

This collection of 13 dragons is loaded with sketches, drawings, anatomical studies, detailed diagrams, brief natural histories and step-by-step color art demonstrations for each creature, showing the process of making dragon images from start to finish. You'll enjoy learning all about dragons and the process of their creation. A bonus full foldout comparison poster of all the dragons in the book is featured!

ISBN-13: 978-1-60061-315-9
ISBN-10: 1-60061-315-2
hardcover, 160 pages, #Z2922

DragonArt Fantasy Characters includes historical facts about fantasy people, a cool flipbook feature on the bottom right-hand pages and the book mascot, Dolosus. You'll experience immediate success by starting with the extremely easy, basic anatomy that most fantasy characters share, then move on to more interesting and complex characters from initial pencils through to shaded and colored finished illustrations. Characters include: dwarves, elves, orcs, goblins, merfolk, fauns, centaurs, werewolves, vampires and more!

ISBN-13: 978-1-58180-852-0
ISBN-10: 1-58180-852-6
paperback, 128 pages, #Z0055

These and other fine *IMPACT* books are available at your local art & craft retailer, bookstore or online supplier.

IMPACT-Books.com

- Connect with other artists
- Get the latest in comic, fantasy, and sci-fi art
- Special deals on your favorite artists

FANTASY GENESIS SETS & LISTS

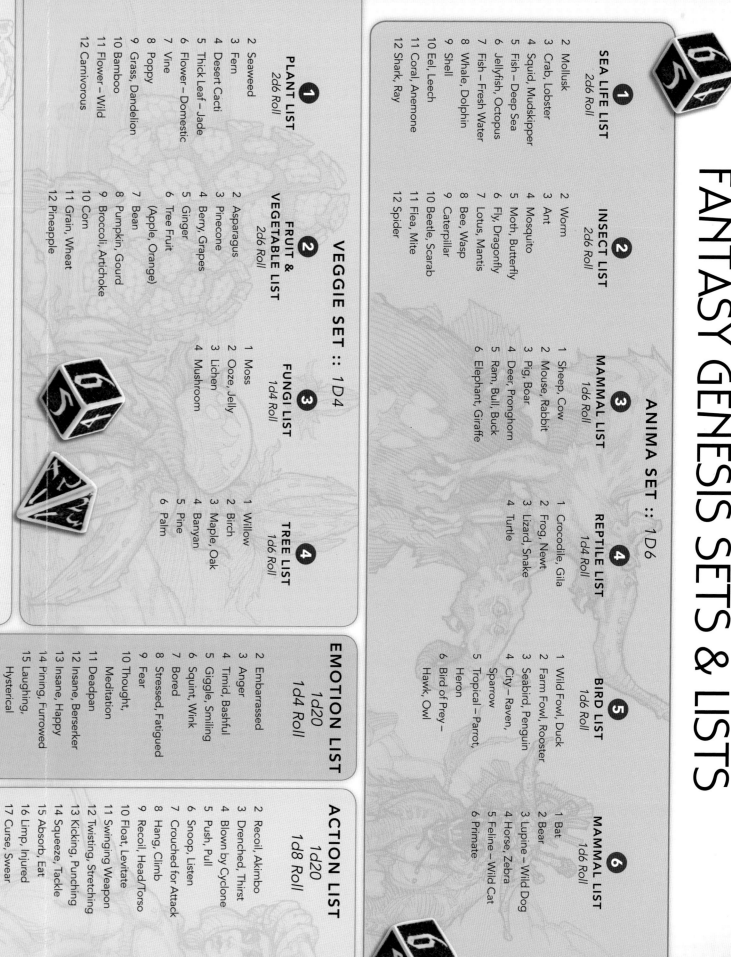
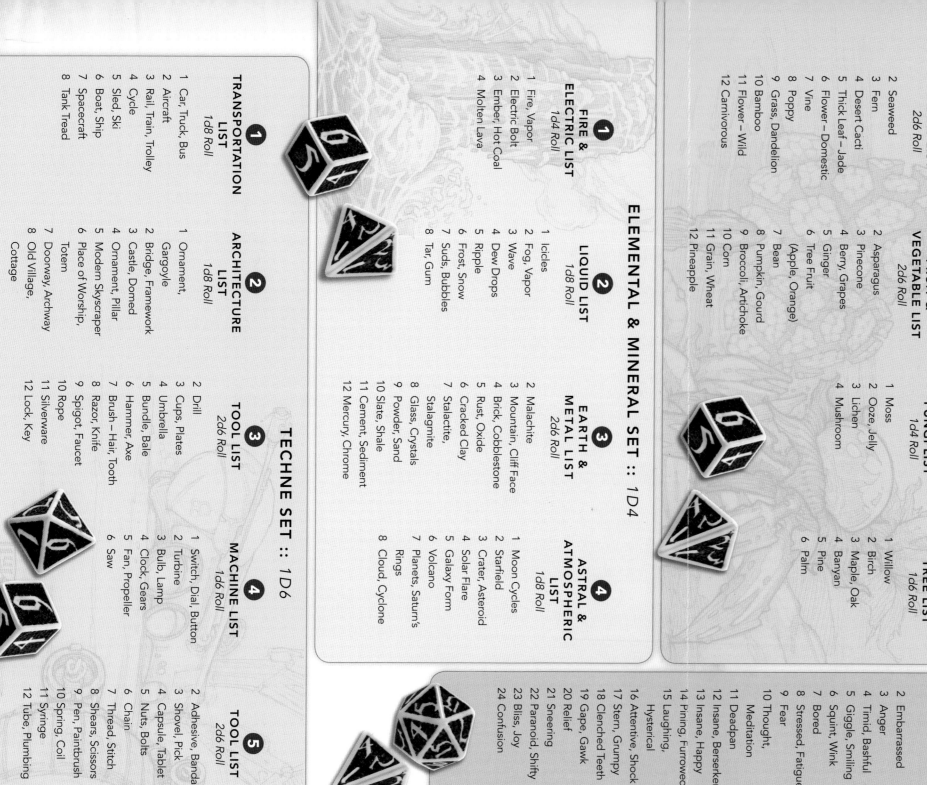

ANIMA SET :: 1D6

1. SEA LIFE LIST — 2d6 Roll
2 Mollusk
3 Crab, Lobster
4 Squid, Mudskipper
5 Fish – Deep Sea
6 Jellyfish, Octopus
7 Fish – Fresh Water
8 Whale, Dolphin
9 Shell
10 Eel, Leech
11 Coral, Anemone
12 Shark, Ray

2. INSECT LIST — 2d6 Roll
2 Worm
3 Ant
4 Mosquito
5 Moth, Butterfly
6 Fly, Dragonfly
7 Lotus, Mantis
8 Bee, Wasp
9 Caterpillar
10 Beetle, Scarab
11 Flea, Mite
12 Spider

3. MAMMAL LIST — 1d6 Roll
1 Sheep, Cow
2 Mouse, Rabbit
3 Pig, Boar
4 Deer, Pronghorn
5 Ram, Bull, Buck
6 Elephant, Giraffe

4. REPTILE LIST — 1d4 Roll
1 Crocodile, Gila
2 Frog, Newt
3 Lizard, Snake
4 Turtle

5. BIRD LIST — 1d6 Roll
1 Wild Fowl, Duck
2 Farm Fowl, Rooster
3 Seabird, Penguin
4 City – Raven, Sparrow
5 Tropical – Parrot, Heron
6 Bird of Prey – Hawk, Owl

6. MAMMAL LIST — 1d6 Roll
1 Bat
2 Bear
3 Lupine – Wild Dog
4 Horse, Zebra
5 Feline – Wild Cat
6 Primate

EMOTION LIST — 1d20 Roll
2 Embarrassed
3 Anger
4 Timid, Bashful
5 Giggle, Smiling
6 Squint, Wink
7 Bored
8 Stressed, Fatigued
9 Fear
10 Thought, Meditation
11 Deadpan
12 Insane, Berserker
13 Insane, Happy
14 Pining, Furrowed
15 Laughing, Hysterical
16 Attentive, Shock
17 Stern, Grumpy
18 Clenched Teeth
19 Gape, Gawk
20 Relief
21 Sneering
22 Paranoid, Shifty
23 Bliss, Joy
24 Confusion

ACTION LIST — 1d20 Roll
2 Recoil, Akimbo
3 Drenched, Thirst
4 Blown by Cyclone
5 Push, Pull
6 Snoop, Listen
7 Crouched for Attack
8 Hang, Climb
9 Recoil, Head/Torso
10 Float, Levitate
11 Swinging Weapon
12 Twisting, Stretching
13 Kicking, Punching
14 Squeeze, Tackle
15 Absorb, Eat
16 Limp, Injured
17 Curse, Swear
18 Run, Jump
19 Melt, Glow, Fire
20 Stuck, Trapped
21 Pull, Push
22 Shoot Weapon
23 Dying, Gaunt
24 Fly, Swim
25 Shed, Molting
26 Chant, Recite
27 Punch, Kick
28 Crawl, Emerge

VEGGIE SET :: 1D4

1. PLANT LIST — 2d6 Roll
2 Seaweed
3 Fern
4 Desert Cacti
5 Thick Leaf – Jade
6 Flower – Domestic
7 Vine
8 Poppy
9 Grass, Dandelion
10 Bamboo
11 Flower – Wild
12 Carnivorous

2. FRUIT & VEGETABLE LIST — 2d6 Roll
2 Asparagus
3 Pinecone
4 Berry, Grapes
5 Ginger
6 Tree Fruit (Apple, Orange)
7 Bean
8 Pumpkin, Gourd
9 Broccoli, Artichoke
10 Corn
11 Grain, Wheat
12 Pineapple

3. FUNGI LIST — 1d4 Roll
1 Moss
2 Ooze, Jelly
3 Lichen
4 Mushroom

4. TREE LIST — 1d6 Roll
1 Willow
2 Birch
3 Maple, Oak
4 Banyan
5 Pine
6 Palm

ELEMENTAL & MINERAL SET :: 1D4

1. FIRE & ELECTRIC LIST — 1d4 Roll
1 Fire, Vapor
2 Electric Bolt
3 Ember, Hot Coal
4 Molten Lava

2. LIQUID LIST — 1d8 Roll
1 Icicles
2 Fog, Vapor
3 Wave
4 Dew Drops
5 Ripple
6 Frost, Snow
7 Suds, Bubbles
8 Tar, Gum

3. EARTH & METAL LIST — 2d6 Roll
2 Malachite
3 Mountain, Cliff Face
4 Brick, Cobblestone
5 Rust, Oxide
6 Cracked Clay
7 Stalactite, Stalagmite
8 Glass, Crystals
9 Powder, Sand
10 Slate, Shale
11 Cement, Sediment
12 Mercury, Chrome

4. ASTRAL & ATMOSPHERIC LIST — 1d8 Roll
1 Moon Cycles
2 Starfield
3 Crater, Asteroid
4 Solar Flare
5 Galaxy Form
6 Volcano
7 Planets, Saturn's Rings
8 Cloud, Cyclone

TECHNE SET :: 1D6

1. TRANSPORTATION LIST — 1d8 Roll
1 Car, Truck, Bus
2 Aircraft
3 Rail, Train, Trolley
4 Cycle
5 Sled, Ski
6 Boat, Ship
7 Spacecraft
8 Tank Tread

2. ARCHITECTURE LIST — 1d8 Roll
1 Ornament, Gargoyle
2 Bridge, Framework
3 Castle, Domed
4 Ornament, Pillar
5 Modern Skyscraper
6 Place of Worship, Totem
7 Doorway, Archway
8 Old Village, Cottage

3. TOOL LIST — 2d6 Roll
2 Drill
3 Cups, Plates
4 Umbrella
5 Bundle, Bale
6 Hammer, Axe
7 Brush – Hair, Tooth
8 Razor, Knife
9 Spigot, Faucet
10 Rope
11 Silverware
12 Lock, Key

4. MACHINE LIST — 1d6 Roll
1 Switch, Dial, Button
2 Turbine
3 Bulb, Lamp
4 Clock, Gears
5 Fan, Propeller
6 Saw

5. TOOL LIST — 2d6 Roll
2 Adhesive, Bandage
3 Shovel, Pick
4 Capsule, Tablet
5 Nuts, Bolts
6 Chain
7 Thread, Stitch
8 Shears, Scissors
9 Microchip
10 Spring, Coil
11 Syringe
12 Tube, Plumbing

6. MACHINE LIST — 1d8 Roll
1 Reactor Core
2 Telephone
3 Solar Panel
4 Engine
5 Laser Beam
6 Microchip
7 Dish Antenna
8 Rocket